"I expect that this book—written c [...] space—will now become the first book I recommend on men and women in the church. Even where I might not agree with every conclusion, all of the positions are represented fairly. Help yourself and your church: read this book and get some copies for others."

**Mark Dever**, Pastor, Capitol Hill Baptist Church; President, 9marks.org

"Kevin DeYoung set out to write a book about the divinely designed complementarity of men and women that had exegetical integrity, used minimal technical jargon, and was weightier than a pamphlet and lighter than a doorstop. He has done just that and much more. *Men and Women in the Church* is readable, accessible, and—despite its brevity—covers all the main texts and common questions. It is an excellent introduction to the goodness of the Bible's teaching about men and women, and about how to live faithfully today."

**Claire Smith**, New Testament scholar; author, *God's Good Design: What the Bible Really Says about Men and Women*

"This is the first book I will recommend to those who want to study what the Scriptures teach about the roles of men and women both in marriage and in the church. In our busy lives it is difficult to find time to read, but here is a concise survey that can be read in an evening. Don't be fooled by the size. The book is vintage DeYoung and is packed with solid exegesis and faithful theology. I was amazed at how much wisdom is packed into this short book. Everything in the book is helpful, but the practical application section alone is worth the price of the book."

**Thomas R. Schreiner**, James Buchanan Harrison Professor of New Testament Interpretation, The Southern Baptist Theological Seminary

"Kevin DeYoung engages forthrightly with the most relevant scriptural texts on men and women in the church, always eager to help us see and understand not only what God is saying in the text but also *why* what God says is for our good. He doesn't avoid hard questions, nor does he apologize or squirm because God did things the way he did. In this book, you are invited to acknowledge that what God has said and done in making men and women for particular purposes is not only real, but good."

**Abigail Dodds,** author, *(A)Typical Woman and Bread of Life*

"This book does not disappoint. It brings the discussion up to date and deals forthrightly and biblically with a number of current challenges to the Bible's teaching about men and women in the church and in the home. Kevin DeYoung's clear, biblical exposition and engaging style make this a joy to read. I cannot recommend this book highly enough."

**Denny Burk,** Professor of Biblical Studies, Boyce College; author, *What Is the Meaning of Sex?*

*Men and Women in the Church*

## Other Crossway Books by Kevin DeYoung

*The Biggest Story: How the Snake Crusher Brings Us Back to the Garden* (2015)

*The Biggest Story ABC* (2017)

*Crazy Busy: A (Mercifully) Short Book about a (Really) Big Problem* (2013)

*Don't Call It a Comeback: The Old Faith for a New Day* (editor; 2011)

*Grace Defined and Defended: What a 400-Year-Old Confession Teaches Us about Sin, Salvation, and the Sovereignty of God* (2019)

*The Hole in Our Holiness: Filling the Gap between Gospel Passion and the Pursuit of God* (2012)

*Taking God at His Word: Why the Bible Is Knowable, Necessary, and Enough, and What That Means for You and Me* (2014)

*The Ten Commandments: What They Mean, Why They Matter, and Why We Should Obey Them* (2018)

*What Does the Bible Really Teach about Homosexuality?* (2015)

*What Is the Mission of the Church?: Making Sense of Social Justice, Shalom, and the Great Commission* (coauthor; 2011)

# Men and Women
# in the Church

*A Short, Biblical, Practical Introduction*

Kevin DeYoung

WHEATON, ILLINOIS

*Men and Women in the Church: A Short, Biblical, Practical Introduction*

Copyright © 2021 by Kevin DeYoung

Published by Crossway
1300 Crescent Street
Wheaton, Illinois 60187

Published in association with the literary agency of Wolgemuth & Associates, Inc.

Cover design: Darren Welch

First printing 2021

Printed in the United States of America

Unless otherwise indicated, Scripture quotations are from the ESV® Bible (The Holy Bible, English Standard Version®), copyright © 2001 by Crossway, a publishing ministry of Good News Publishers. Used by permission. All rights reserved.

Scripture quotations marked NASB are from *The New American Standard Bible*®. Copyright © 1960, 1962, 1963, 1968, 1971, 1972, 1973, 1975, 1977, 1995 by The Lockman Foundation. Used by permission. www.Lockman.org.

Scripture quotations marked (NIV) are taken from the Holy Bible, New International Version®, NIV®. Copyright © 1973, 1978, 1984, 2011 by Biblica, Inc.™ Used by permission of Zondervan. All rights reserved worldwide. www.zondervan.com. The "NIV" and "New International Version" are trademarks registered in the United States Patent and Trademark Office by Biblica, Inc.™

Scripture quotations marked (NLT) are taken from the Holy Bible, New Living Translation, copyright © 1996, 2004, 2015 by Tyndale House Foundation. Used by permission of Tyndale House Publishers, a Division of Tyndale House Ministries, Carol Stream, Illinois 60188. All rights reserved.

Scripture quotations marked NRSV are from *the New Revised Standard Version Bible*, copyright © 1989 the Division of Christian Education of the National Council of the Churches of Christ in the United States of America. Used by permission. All rights reserved.

Scripture quotations marked RSV are from *the Revised Standard Version of the Bible*, copyright © 1946, 1952, and 1971 the Division of Christian Education of the National Council of the Churches of Christ in the United States of America. Used by permission. All rights reserved.

All emphases in Scripture quotations have been added by the author.

Trade paperback ISBN: 978-1-4335-6653-0
ePub ISBN: 978-1-4335-6656-1
PDF ISBN: 978-1-4335-6654-7
Mobipocket ISBN: 978-1-4335-6655-4

## Library of Congress Cataloging-in-Publication Data

Names: DeYoung, Kevin, author.
Title: Men and women in the church : a short, biblical, practical introduction / Kevin DeYoung.
Description: Wheaton, Illinois : Crossway, 2021. | Includes bibliographical references and index.
Identifiers: LCCN 2020036376 (print) | LCCN 2020036377 (ebook) | ISBN 9781433566530 (trade paperback) | ISBN 9781433566547 (pdf) | ISBN 9781433566554 (mobipocket) | ISBN 9781433566561 (epub)
Subjects: LCSH: Sex role--Biblical teaching. | Sex role—Religious aspects--Christianity. | Men (Christian theology) | Women—Religious aspects--Christianity.
Classification: LCC BS680.S53 D4 2021 (print) | LCC BS680.S53 (ebook) | DDC 261.8/357--dc23
LC record available at https://lccn.loc.gov/2020036376
LC ebook record available at https://lccn.loc.gov/2020036377

Crossway is a publishing ministry of Good News Publishers.

BP          30    29    28    27    26    25    24    23    22    21
15    14    13    12    11    10    9    8    7    6    5    4    3    2    1

*To Trisha*
*"For better, for worse"—and you make everything better.*

# Contents

# Introduction

## What If? How Come?
## Where Are We Going?

WE GET SO USED TO the way things are that we rarely stop to consider how things could have been drastically different.

Kaiser Wilhelm II was the king of Prussia and the last German emperor. Reigning from June 1888 to November 1918, Wilhelm was an ambitious, volatile, and aggressive ruler whose policies in Europe were partly to blame for World War I.

In 1889, when Wilhelm had barely been on the throne for a year, a special event was taking place at Berlin's Charlottenburg Race Course: Buffalo Bill's *Wild West* show. The show had arrived from America and was touring all over Europe. At one point in the show, Annie Oakley announced that she was going to shoot the ashes off of a cigar with her Colt .45. Then, as was her custom, she asked if anyone from the audience wanted to volunteer to hold the cigar. The question was meant as a joke. People were supposed to laugh, and then, when no one came

forward, Annie would have her husband hold the cigar just like he always did.

But this time, at the Berlin race course, after Annie made the humorous announcement, an important man from the royal box walked into the arena and volunteered to hold the cigar. It was Kaiser Wilhelm. Some German policemen tried to stop him, but he waved them off. With a mixture of hubris, courage, and stupidity, Wilhelm insisted on holding the cigar. Annie Oakley couldn't back out now, so she paced off her usual distance and prepared to shoot.

And what happened next? According to one historian: "Sweating profusely under her buckskin, and regretful that she had consumed more than her usual amount of whiskey the night before, Annie raised her Colt, took aim, and blew away Wilhelm's ashes."[1] The same historian goes on to wonder how the world might have been different if she had missed the cigar and creased the Kaiser's head instead. Perhaps an entire world war would have been avoided.

Years later, after the First World War began, Annie Oakley wrote to Wilhelm asking if she could have a second shot. He never replied.

### The Way Things Are (and Were Designed to Be)

The story above comes from *What If?*—an aptly titled book full of counterfactual history. Instead of analyzing what took place and why, in counterfactual history scholars imagine what might have been. What if Alexander the Great had lived to be an old man? What if the Spanish Armada had defeated the English? What if the fog had not rolled in, allowing George Washington's

army to escape Brooklyn after being badly beaten at the Battle of Long Island? What if the Soviets had invaded Japan at the close of World War II? We get so used to the way things are that we rarely consider how things could have been drastically different.

What is true for history is true for life more generally. Is there any one aspect of human life that has affected every other aspect of human life more than being male or female? While my life is certainly not reducible to being a man, everything about my life is shaped by the fact that I am male, not female. My wife's whole life is shaped by being a woman and not a man. Each of my nine children (yes, we wanted to start our own baseball team) are undeniably and monumentally shaped by being boys or girls. And yet how often do we stop to think that it didn't *have* to be this way? God didn't have to make two different kinds of human being. He didn't have to make us so that men and women, on average, come in different shapes and sizes and grow hair in different places and often think and feel in different ways. God could have propagated the human race in some other way besides the differentiated pair of male and female. He could have made Adam sufficient without an Eve. Or he could have made Eve without an Adam. But God decided to make not one man or one woman, or a group of men or a group of women; he made a man *and* a woman. The one feature of human existence that shapes life as much or more than any other—our biological sex—was God's choice.

In an ultimate sense, of course, the world had to be made the way it was, in accordance with the immutable will of God and as a necessary expression of his character. I'm not suggesting God made Adam and Eve by a roll of the dice. Actually, I'm reminding us of the opposite. This whole wonderful, beautiful, complicated

business of a two-sexed humanity was God's idea. "So God created man in his own image, in the image of God he created him; male and female he created them" (Gen. 1:27). The whole human race is, always has been, and will be for the rest of time, comprised of two differentiated and complementary sexes. This perpetual bifurcated ordering of humanity is not by accident or by caprice but by God's good design.

And why? What is at stake in God making us male and female? Nothing less than the gospel, that's all. The mystery of marriage is profound, Paul says, and it refers to Christ and the church (Eph. 5:32). "Mystery" in the New Testament sense refers to something hidden and then revealed. The Bible is saying that God created men and women—two different sexes—so that he might paint a living picture of the differentiated and complementary union of Christ and the church. Ephesians 5 may be about marriage, but we can't make sense of the underlying logic unless we note God's intentions in creating marriage as a gospel-shaped union between a differentiated and complementary pair. Any move to abolish all distinctions between men and women is a move (whether intentionally or not) to tear down the building blocks of redemption itself.

Men and women are not interchangeable. The man and the woman—in marriage especially, but in the rest of life as well—complement each other, meaning they are supposed to function according to a divine fitted-ness. This is in keeping with the ordering of the entire cosmos. Think about the complementary nature of creation itself. "In the beginning, God created the heavens and the earth" (Gen. 1:1). And that's not the only pairing in creation. We find other sorts of couples, like the sun and the moon, morn-

ing and evening, day and night, the sea and the dry land, and plants and animals, before reaching the climactic couple, a man and a woman. In every pairing, each part belongs with the other, but neither is interchangeable. It makes perfect sense that the coming together of heaven and earth in Revelation 21–22 is preceded by the marriage supper of the Lamb in Revelation 19. That God created us male and female has cosmic and enduring significance. From start to finish, the biblical storyline—and design of creation itself—depends upon the distinction between male and female as different from one another yet fitted each for the other.[2]

## Simple Book, Simple Aim

So what is this book about? In simplest terms, this book is about the divinely designed complementarity of men and women as it applies to life in general and especially to ministry in the church.[3]

You may be thinking, "How can we possibly need another book on this subject?" And it's true—much has been written on this topic over the last generation, some of it forgettable and some of it quite good.[4] You should read the books. I don't claim mine is the best of the bunch. What I can claim is that this book is shorter than the rest. We need books that give a comprehensive survey of biblical passages about men and women. We need books that engage with history, science, and philosophy as they relate to manhood and womanhood. We need books that deal explicitly with the challenges of gender confusion and toxic masculinity and secular feminism. There is a lot that can be said about sex and gender, and a lot that needs to be said.

This is your fair warning that I'm not trying to say everything, or even a small fraction of a lot.

I have a very specific audience in mind in writing this book: my congregation and others like it. Our church has a book nook in the corner of our main lobby. I have often wished for a book there that explained the Bible's teaching about men and women in the church in a way that the interested layperson could understand and in a size that he or she could read in a few hours. I have wished for a book that would argue its case without being argumentative; a book I could give to other pastors wrestling with this issue; and a book pastors could give to their elders, deacons, and trustees that they would actually read; a book that displays exegetical integrity with minimal technical jargon; a book weightier than a pamphlet but lighter than a doorstop. You'll have to decide if I've written such a book, but that is the book I set out to write.

## A Personal Note and the Plan Ahead

As far as I know my own heart, this is not an axe-to-grind kind of book. Or, if I can mix my metaphors, I'm hoping to give you meat and potatoes, not fire-hot salsa. If you are among those who are looking for an introductory and non-angsty walk through the requisite biblical texts on men and women in the church, with an eye toward clarification and application, then this might be the book for you.

Having said that, I want to speak directly to two types of people. First, I want single people to know this is not a book about marriage. True, the chapter on Ephesians 5 is about marriage, and many of the patterns of God-given sexual difference find their clearest expression in marriage. And yet I'd be loathe for anyone to conclude that you can't *really* be manly or womanly unless you are married. By the same token, I hope no one concludes

that if we are single, the Bible doesn't *really* have a lot to say to us about being a man or a woman. As we will see, the fact that God created man as a plurality—male and female, a complementary pair—ought to shape not only how we conceive of marriage but how we conceive of ourselves.

Second, I want to say something to the men and women—no doubt, mostly women—who have been hurt in contexts where the truths I'm going to lay out in this book were affirmed. Oftentimes, the biggest hindrances to believing and resting in biblical truth are not objections of the mind but objections of the heart and of the eyes. It's one thing to be convinced that complementarian exegesis is correct; it's another to be sure that it is good. Like any biblical teaching, the truths about men and women can be misapplied, mishandled, or used as an excuse to mistreat others. This danger is especially poignant when the truths in question affirm the man as leader and head and the woman as helper and nurturer. The biblical pattern of male leadership is *never* an excuse for ignoring women, belittling women, overlooking the contributions of women, or abusing women in any way. The truest form of biblical complementarity calls on men to protect women, honor women, speak kindly and thoughtfully to women, and to find every appropriate way to learn from them and include them in life and ministry—in the home and in the church.

It's important for me to recognize that I've seen in my life mainly healthy gender dynamics. My parents love each other. My churches have been full of godly, intelligent, flourishing, strongly complementarian women. Most of my friends have very good marriages. Whatever I know to be true in my head about abuse or whatever I've seen of sin and dysfunction in marriages

in nearly twenty years of pastoral ministry, there's no doubt that it still *feels* deep in my psyche like most husbands are bound to be pretty good and most complementarian men are apt to be fundamentally <u>decent</u>. I don't have a bunch of stories of boneheaded complementarians. But I don't deny they are out there—men in our circles saying and doing awkward, offensive, or genuinely sinful things toward women in the church. That I don't see them doesn't make them unreal, and that other people have seen them does not make them ubiquitous. My point is we should all be aware that we tend to assume our experiences are normative and the divergent experiences of others are exceptional. This should make us quick to sympathize and slow to accuse.

So what *is* the most pressing issue facing the church today when it comes to men and women?

There is no scientific answer to that question. It may seem obvious to you that gender confusion is the big issue, or abuse or runaway feminism or a wrongheaded complementarianism or the worth of women or the war on boys. I would be foolish to say you aren't seeing what you think you are seeing. For all I know, you've been surrounded by male creeps your whole life. Our assessment of what surely everyone knows and what surely everyone must be warned against may be understandably different.

Don't get me wrong, I'm not calling for an easy intellectual relativism that says, "I guess we are all equally right (or wrong)." I'm suggesting that we should be honest—first of all with ourselves—about what we perceive to be the biggest dangers and why. In recognizing our own inclinations, hopefully we will be less likely to project the worst of the dangers we see upon those who rightfully see other dangers.

## The Case to Be Made

I do not write this book hesitating between two opinions. I am a convinced complementarian. I know some people are tired of that word, *complementarian*, and you'll see me use the words *traditional* or *historic* as well. But there is something important about the word *complementarity* in all its forms. As we've already seen, it's hard to tell the story of the Bible without a word that communicates "different but fitting together." *Complementary*—though I cringe every time I have to text such a long word on my phone—is a good word toward that end. I'm not writing because I think everyone has to use the word. But we have to start somewhere, so I might as well tell you where I am coming from and where this book is going.

As a complementarian, I believe that God's design is for men to lead, serve, and protect, and that, in the church, women can thrive under this leadership as they too labor with biblical faithfulness and fidelity according to the wisdom and beauty of God's created order. It goes without saying that I hope to make a convincing case for the complementarian position. Authors do not write books unless they want to persuade people.

But besides convincing, I also hope my case is considerate. The Lord's servant "must not be quarrelsome but kind to everyone, able to teach, patiently enduring evil, correcting his opponents with gentleness" (2 Tim. 2:24–25). My aim is to treat others, whether in person or in writing, as I would want to be treated—fairly, honestly, and with respect. Even as I write, I see in my mind the faces of friends, family, and colaborers I love who don't see eye to eye with me on this issue—sometimes on first principles and

more often in practice. I may disagree with their position and even think they are wrong on important interpretive points, but I do not want to disparage their person or demean their sincerity in following Christ.

My overriding desire is to put into the hands of churches, leaders, and curious Christians a work that is intelligent and readable. In hopes of being an intelligent help for congregations, I work through the pertinent Scripture passages, including several chapters of fairly detailed exegesis, and a smattering of (transliterated) Greek and Hebrew words. In hopes of being readable, I have tried to be concise, brief, and informed of the current debates without getting bogged down in footnotes except where attribution is necessary.

Our road map is simple. We'll start with biblical exploration in part 1 and then move to questions and applications in part 2. Along the way I hope you will be convinced, as I am, that God made men and women not only to worship, serve, and obey him, but to worship, serve, and obey him *as* men and women.

PART 1

———————

# BIBLICAL
# EXPLORATION

# 1

# A Very Good Place to Start

## Genesis 1–3

I'VE HEARD IT SAID that "all good theology starts in Genesis." That's not far off the mark. In Genesis, we see how God started things. We have the beginning of the story. In the first two chapters of Genesis, God gives us a stunning picture of paradise, a portrait of the good life—the way things were, the way they are supposed to be, and the way they will be again.

In Eden, all was very good. The natural world was good, with its striking beauty and peaceful cooperation. The creation of man—from the dust of the earth to the crown of creation—was good. Work was good. No broken tractors, no computer viruses, no coronaviruses, no thorns and thistles, no anxious deadlines, no cranky bosses, no incompetent employees, no power plays; just an honest day's work under the smiling face of God. And the garden, as a kind of temple in which God's presence dwelt, was good.

But even before the fall, even in this paradise, there was one thing which, if left undone, would not have been good: leaving man alone. That's what Genesis 2 tell us as it zooms in on Genesis 1:27 on the sixth day before the pronouncement of Genesis 1:31 at the close of the day.

We do not know that Adam was lonely or that he felt isolated. The text never suggests a psychologized problem. As we will see, the problem with Adam's aloneness was something else. But it was a problem. There is no record of the man complaining to God that he was alone. Instead, God himself declared that Adam's situation was not good (Gen. 2:18). Every other aspect of creation had its counterpart. The day had its sun, the night its moon, the waters its fish, the sky its birds, and the ground its animals, but the man did not have his helpmate. "So the LORD God caused a deep sleep to fall upon the man, and while he slept took one of his ribs and closed up its place with flesh. And the rib that the LORD God had taken from the man he made into a woman and brought her to the man" (Gen. 2:21–22). This was very good.

## Male and Female from the Beginning

The Bible gives us only two chapters on the creation of the world before the fall. If we're honest, most of us would like more information. Where exactly was the garden of Eden? What did it look like? What did it smell like? Were the days normal twenty-four-hour days? How old did Adam appear to be? How old did the trees appear to be? Were there mosquitoes? But of all the things we might want to know more clearly, it's worth noting what God *does* tell us about in some detail. He tells us quite a bit about the

man and the woman—how they are the same, how they are different, and how they were made for each other.

If we are to think rightly and feel rightly and embrace rightly what it means to be male and female, we need to appreciate that God doesn't give arbitrary rules for men and women to follow. Whatever "rules" there are for men and women in the church are never mere rules; they reflect the sort of differentiated and complementary image bearers God designed us to be from the beginning. Once we understand the first chapters of Genesis, and how God has embedded sexual differentiation and sexual union (in marriage) in the natural order of the created world, everything else we see in the Bible about being a man or being a woman makes more sense. All good theology starts in Genesis, but it never stops there.

## The Start of It All

And how much do the opening chapters of Genesis really say about manhood and womanhood? I'll limit myself to fifteen *haha* observations.

First, the man and the woman were both created in the image of God. "So God created man in his own image, in the image of God he created him; male and female he created them" (Gen. 1:27). Men and women, as distinct from all else in creation, are image bearers. We are like statues or icons placed in creation to testify to the world that God has dominion over this place. As image bearers, not to mention coheirs of the grace of life (1 Pet. 3:7), men and women possess equal worth and dignity. Eve was not a lesser creature. She was not an inferior being. Although God has revealed himself in masculine language (e.g., father, king, *inferior in what sense?*

*True but there is
a reason why he is
referred to as a "man"*

husband), he is neither male nor female. To be faithful to God's revelation, we should speak of God only in the masculine terms he has given us, but to call God "Father" is not the same as saying God is a man (though he became a man in the incarnation). Maleness, therefore, is not a higher order of being than femaleness. Both men and women were made to represent God in the world.

Second, man has both singularity and plurality.[1] Humanity can be named singularly as *adam* ("man" not "woman"), but humanity is at the same time male and female. There is a "him" and a "them" (Gen. 1:27). The way the creation account spells out sexual difference is so obvious that we can miss its importance. God does not mention the difference of, say, height or hair color or temperament or gifting. The one identity marker emphasized at the beginning is maleness and femaleness.

Third, the man and the woman were given joint rule over creation. Together they were to fill the earth and subdue it. God blessed *them*, and God told *them* to have dominion over every living thing (Gen. 1:28).

Fourth, within this joint rule, the man and woman were given different tasks and created in different realms. "The LORD God took the man and put him in the garden of Eden to work it and keep it" (Gen. 2:15). Adam was created outside of the garden and charged with cultivating it and protecting it, a protection under which the woman was meant to flourish. Eve was created within the garden, suggesting "a special relationship to the inner world of the Garden."[2] The creation mandate—filling the earth and subduing it—applies to both sexes, but asymmetrically. The man, endowed with greater biological strength, is fitted especially for tilling the soil and taming the garden, while the woman,

possessing within her the capacity to cultivate new life, is fitted especially for filling the earth and tending to the communal aspects of the garden.]

Fifth, man was given the priest-like task of maintaining the holiness of the garden. To the man alone God gave the command: "You may surely eat of every tree of the garden, but of the tree of the knowledge of good and evil you shall not" (Gen. 2:16–17). In working and keeping the garden (2:15), the man was responsible for establishing God's command on the earth and guarding God's moral boundaries. His obedience to this task would mean blessing, while his disobedience would mean death.

*This is how Adam sinned*

Sixth, man was created before the woman. Famously, Paul grounded his prohibition against women teaching in the church based on this order. "I do not permit a woman to teach or to exercise authority over a man; rather, she is to remain quiet. For Adam was formed first, then Eve" (1 Tim. 2:12–13). The point is not "first equals best," as if God was picking sides for his kickball team. After all, God made blue jays and beavers and salamanders before he made man. The order matters because it indicates Adam's position in the creation narrative as priest and protector and Eve's position as coming under the man's protection, made from his side and for his support.

Seventh, the woman was given as a helper to the man. Eve was created *from* man (Gen. 2:22)—equal in worth—and she was also created *for* man (2:20)—different in function. The male leadership, which the text hints at in Genesis 1:27 by calling male and female "man," is spoken plainly in chapter 2 when Eve is given to Adam as his "helper" (2:18, 20). Being a helper carries no connotations of diminished worth or status; for God is

sometimes called the helper of Israel (Ex. 18:4; Pss. 33:20; 146:5). *Ezer* (helper) is a functional term, not a demeaning one. Just as God at times comes alongside to help his people, so the role of the woman in relationship to her husband is that of a helper. "For man was not made from woman, but woman from man. Neither was man created for woman, but woman for man" (1 Cor. 11:8).

We tend to psychologize Adam's aloneness and interpret "helper" along the lines of comfort and companionship. This is one possible aspect of the term. Calvin said Eve was God's gift to Adam "to assist him to live well." But "helper" cannot be divorced from the broader concerns of the creation mandate. It was not good for man to be alone because by himself he could not "be fruitful and multiply and fill the earth" (Gen. 1:28). Here again we see the ordered complementarity of male and female. Another man could have helped Adam till the soil. Another man could have provided relational respite and energy for Adam. God could have gifted Adam a plow or a team of oxen or a fraternity of manly friends—all of which would have been useful, even delightful. But none would have been a helper fit for the crucial task of producing and rearing children. If mankind is to have dominion on the earth, there must be a man to work the garden and a woman to be his helpmate.

Eighth, the man was given the responsibility for naming every living creature. It is telling that Adam alone was given this exercise of dominion and that he was able to fulfill this responsibility prior to the creation of Eve. Twice Adam named the woman (2:23; 3:20), indicating his leadership. In receiving their names from Adam, the rest of the living creatures, including the woman, benefit from the man's creative cultivation and authority.

Ninth, the man and the woman were created in different ways. Genesis 1 describes the making of male and female as a generic act of creation (1:27). In the zoom lens of Genesis 2, however, we see that God created each in its own way. The Lord God formed the man of dust from the ground (2:7), while the Lord God built the woman from the rib he had taken from the man. [Not surprisingly, the man is tasked with tending to the health and vitality of the ground from which he came, while the woman is tasked with helping the man from whom she came.] The way in which each was created suggests the special work they will do in the wider world—the man in the establishment of the external world of industry, and the woman in the nurture of the inner world of the family that will come from her as helpmate.

Tenth, the names "man" and "woman" suggest interdependence. In Genesis 2:23, Adam exclaimed, "She shall be called Woman [*ishah*], because she was taken out of Man [*ish*]." Providentially, our English words show the connection that is there in the Hebrew. We lose something deeply important in the awkward intersectional neologisms that turn *woman* into *womxn* and *women* into *womyn*. We lose all verbal recognition that the woman came from the man and that the man was irreversibly connected to the woman. "In the Lord woman is not independent of man nor man of woman; for as woman was made from man, so man is now born of woman" (1 Cor. 11:11–12).

Eleventh, in marriage, the man leaves his family and holds fast to his wife. Given everything we've seen up to this point, we expect that the wife would leave her family and cling to her husband. Wasn't he created first? Isn't he the keeper of the garden and protector of all therein? Didn't he exercise authority in naming the

woman? Surely the helper leaves her family to join her husband. But we are told the opposite, that the man shall leave his father and mother (Gen. 2:24). This makes sense when we realize that sexual differentiation is not about first place and second place, but about natural order and design. The inner world of the garden, radiating out from the family, is shaped by the help and nurture of the woman. Emotional intimacy and communion will be fostered and formed in a unique way by the woman. As such, in a relational sense (even if not in a geographic or legal sense), her familial order takes precedence over the man's.

Don't we see this reality even today? When a daughter gets married, you gain a son more than you lose a daughter. When a son gets married, you lose a son more than you gain a daughter. Not true across the board, of course. And yet even when both bride and groom come from healthy, loving families, the daughter almost always maintains her familial relationships better than the son. The Genesis account is not telling men to renounce their families of origin, but it is telling us something significant about the way relational bonds are typically formed and maintained through women.

Twelfth, the two came from one flesh and became one flesh. Eve was bone of Adam's bone and flesh of his flesh. Men and women are made of the same stuff and meant for each other, not so that one dissolves into the other, but that the two become one. Marriage must be, and can only be, between a man and a woman, because marriage is not just the union of two persons but the re-union of a complementary pair. As Calvin puts it, "Something was taken from Adam, in order that he might embrace, with greater benevolence, a part of himself." Adam may have lost a rib, but he

gained a far richer reward, "since he obtained a faithful associate of life; for he now saw himself, who had before been imperfect, rendered complete in his wife."[3]

*Patriarch*

Thirteenth, Adam is reckoned as the head and representative of the couple. Adam is given the initial command regarding the tree of the knowledge of good and evil (Gen. 2:16–17). And even though Eve, tempted by the serpent, commits the initial crime, Adam is addressed first (3:9). The Lord called to the man and asked, "Where are you?" for Adam was the designated leader and representative. Romans 5 makes this indisputably clear: "Therefore, just as sin came into the world *through one man*, and death through sin, and so death spread to all men because all sinned" (5:12). In other words, Adam, not Eve, was the federal head.

Fourteenth, the man and the woman experience the curse in different ways, each in their fundamental area of responsibility. In the fall—and subsequently as a result of the fall—the divinely designed complementarity of men and women is perverted. Eve, who was deceived into sin, did so acting independently of the man, while Adam abandoned his responsibilities as a leader (Gen. 3:6). He stood idly by while Eve sinned (3:1–5), followed her into sin (3:6), and then blamed God for giving him Eve in the first place (3:12). Adam's sin was not only in disobeying God's command (2:17), but also in throwing off his responsibility as familial head, playing the coward, and following his wife's influence instead of God's word.

So in the end, both are punished for their disobedience. For man, his unique domain—working the ground—is cursed (3:17). From now on, he will have thorns and thistles to deal with (3:18), and he will live by the sweat of his brow (3:19). For woman, her

unique domain—childbearing—will bear the effects of the curse (3:16a). From now on, the miracle and gift of physical birth will be attended with pain and suffering. Technically, only the snake and the ground are cursed, not the man and the woman, but all of creation bears the effects of the fall. Men and women are subjected to frustration in their unique spheres of responsibility.

Fifteenth, the relational wholeness between the man and the woman had been ruptured by the curse. God said to the woman, "Your desire will be for your husband, and he will rule over you" (3:16b NIV). The word *desire* there does not mean romantic desire, as if God cursed the woman by making her need a man. Rather, the desire is a desire for mastery. This is the same Hebrew word used in Genesis 4:7b (NIV): "Sin is crouching at your door; it desires to have you, but you must rule over it." That the meaning of *desire* in 3:16 is the same as the *desire* in 4:7 is clear from the obvious verbal parallel between the two verses:

> 3:16b. Your desire will be for your husband, and he will rule over you. *w'el–ishek tishuqatek wehu yimshal–bak*

> 4:7b. It desires to have you, but you must rule over it. *w'elek teshuqatu w'atah timshal–bo*

Just as sin desired to have mastery over Cain, so the woman, tainted by sin, desires to have mastery over her husband. Because you have listened to the voice of your wife, God says to the man, you will get what you deserve, and she will try to master you (3:17).

The sinful husband, for his part, seeks to rule over his wife. Female subordination itself is not God's judgment on the woman.

As Gordon Wenham notes, the fact "that woman was made from man to be his helper and is twice named by man (2:23; 3:20) indicates his authority over her." Consequently, Adam's rule in verse 16 "represents harsh exploitative subjugation."[4] Wherever husbands are domineering or abusive toward their wives, this is not a reflection of God's design but a sinister perversion of it. The marriage relationship, which was supposed to be marked by mutually beneficial headship and helping, becomes a fight over sinful rebellion and ruling. God designed sexual difference *for* one another; sin takes sexual difference and makes it *opposed* to one another.

## Summary

The importance of the first three chapters of Genesis for understanding what it means to be male and female cannot be overstated. To be clear, Genesis does not give men and women their marching orders. There aren't a lot of explicit oughts laid down for manhood and womanhood. What we have instead are a host of divine patterns and assumptions. Think creational capacities for men and women, not ironclad constraints. The man's primary vocation is "naming, taming, dividing, and ruling." The women's primary vocation involves "filling, glorifying, generating, establishing communion, and bringing forth new life."[5] While it's true that these callings find a unique and powerful expression in marriage, the lessons from Genesis 1–3 are not just for married couples. The opening chapters of the Bible establish the shape of sexual differentiation and complementarity that will be lived out, applied, and safeguarded in the rest of Scripture.

The phrase "biblical manhood and womanhood" has fallen on hard times, and perhaps some of the wounds have been self-inflicted. But at its best, biblical manhood and womanhood is about nothing less than the joyful appropriation of all that God meant for us to be in the garden, divinely fitted for working and helping, for protecting and flourishing, for leaving and cleaving, for filling the earth and subduing it. That's what God saw at the close of the sixth day, and behold, it was very good.

## 2

# Patterns That Preach

## Old Testament Survey

PREACHERS LIKE ALLITERATION. I admit I've used my fair share. And for some reason, P is a popular letter for sermonic points (see how easy it is to get the P's flowing!). So with apologies, let me briefly mention three P words that are particularly pertinent to our exploration of several Old Testament passages (okay, I'll stop).

Whenever we talk about biblical manhood and womanhood we must distinguish among *prescriptions, principles, and patterns.*

- Later we will come to several key *prescriptions* regarding men and women. Most of these prescriptions are found in Paul's letters. Some are positive (do this), and some are negative (don't do that). They form the clearest boundaries for male and female dress, behavior, attitudes, and responsibilities.

- Just as important but less immediate are *principles*, fundamental truths about what men and women are like and what they were created to be. We can glean these sorts of principles from Genesis to Revelation. Paul, for example, in writing to Timothy, applies certain principles from Genesis to the situation in Ephesus.

- And, finally, the Bible reveals *patterns* of behavior for men and women and their mutual interaction. This is especially true in the Old Testament. We always need to be careful in using patterns, lest we turn a description into a prescription. And yet the more often we see something in the Bible, the more appropriately we can derive principles from the patterns—especially if the pattern is consistent, if it is associated with noble characters, and if it reflects the design in Genesis.

All of this is to remind us that while the Old Testament doesn't mean to give us explicit instructions about men and women in the church, the Old Testament *does* show us a lot about men and women in general, and these patterns ought to shape how we think of sexual differentiation and complementarity in life and ministry.

Here are five such patterns.

### Pattern 1: Only Men Exercising Official Leadership

From start to finish, the leaders among God's Old Testament people were men.

We see this pattern first of all with the patriarchs: Abraham, Isaac, and Jacob. Though imperfect men to be sure, they were responsible for the safety and well-being of their families. The Old Testament doesn't emphasize the father's rule in ancient Israel

as much as it underscores the central role the father fulfilled as the provider and protector of the household. We could call this *patricentrism* instead of *patriarchy*, though rightly understood the latter term is not inappropriate.[1]

Following the patriarchs, we see that the leaders of the exodus and the conquest were men: Moses, Aaron, and Joshua. As Israel's worship and polity developed, we see that the leaders under Moses were all men (Ex. 18:21–22). The priests and Levites were all men. The judges, with one exception, were all men. The priests, of every rank, were all men. The monarchs of Israel, with one exception, were all men. The most significant public prophets—people such as Elijah and Elisha, or Isaiah and Jeremiah and Ezekiel—were all men. All the writing prophets were men. All those who rightfully occupied a governing office in Israel were men.

What about the apparent exceptions? I'll have more to say about some of these women later in this chapter, and then I'll return to a few of the exceptions in more detail in the second half of the book. But for now, let me make a few quick observations.

1. As a judge, Deborah did not exercise a military function but came alongside Barak when he failed to go into battle by himself (Judg. 4:8). It was to Barak's shame that his enemy would have to be killed by a woman (4:9, 21–22; 9:53–54). Moreover, the judges in Israel were national deliverers more than formal officers with constituted authority.

2. Several women prophesied in the Old Testament, including Miriam, Deborah, and Huldah. These prophetesses in Israel should be celebrated, but they possessed no institutional authority and did not exercise the same kind of public ministry as many of their male counterparts.

3. Esther was a heroic queen, but she was not the ruling monarch, and she did not serve over Israel.

4. Athaliah was the only women to sit on the throne over Israel, but she rose to be queen not by God's choosing or anointing but by assassinating all the royal heirs (2 Kings 11:1). When the rightful heir, Joash, is later revealed, Athaliah is deposed and put to death (11:13–16). Her reign, far from a notable exception to the rule, underscores the Old Testament notion that it was a sign of declension and embarrassment for women to rule over God's people (Isa. 3:12).

## Pattern 2: Godly Women Displaying a Wide Range of Heroic Characteristics

We should not equate male leadership with female passivity. Women are not bit players in the drama of redemptive history. The Old Testament is full of heroic women influencing history, exercising personal agency, and displaying a range of godly virtues. The daughters of Zelophehad stood up for their families' land inheritance (Num. 27; 36). Jael drove a spike through Sisera's skull (Judg. 4:17–23; 5:24–30). The Shunamite woman appealed to the king for her house and her land (2 Kings 8:3). These are not wallflower women, just hanging about in the background. They are examples of strength, courage, and resourcefulness.

Think of the godly woman in Proverbs 31. Her virtue is primarily in helping her husband—he trusts in her (31:11), she does him good and no harm (31:12)—and in maintaining her household (31:27). This is the pattern we would expect from the creation account in Genesis. But don't miss all that is excellent in

*yes, but their fathers + husbands should have done it*

this "homemaking" wife. She sells wool and flax (31:13). She rises early and stays up late (31:15, 18). She buys a field and plants a vineyard (31:16). She makes coverings and clothing (31:18, 24). *[not her]* She is generous (31:20). She speaks wisely and teaches kindness *[we see]* (31:26). She is a <u>strong</u> woman clothed in dignity (31:17, 25). *[vs strong today]* No doubt this is an idealized picture meant to serve as a capstone to the book that exhorts the reader to pursue Lady Wisdom. We do not want women to be deflated every time they come to the dreaded Proverbs 31 woman. Instead they ought to be encouraged by the picture of a woman exercising all her physical, mental, and entrepreneurial powers by serving—with a broad array of virtues—her husband and her household.

## Pattern 3: Godly Women Helping Men

Quick test: who are some of the most famous and exemplary women in the Old Testament? Don't think too hard or too long. Who came to mind? Probably names such as Sarah and Rebekah, Rachel and Leah, Rahab and Ruth, Deborah and Abigail, Eve and Esther. To be sure, there were imperfect women marked, at times, by disobedience (Eve), unbelief (Sarah), and deception (Rebekah). But where these women are exemplary, it is often on account of the good influence they exercised in steering, advising, assisting, and coming alongside men. Sarah modeled respect for her husband (1 Pet. 3:6). Rahab hid the two spies (Josh. 2). Deborah strengthened the resolve of Barak (Judg. 4). Ruth convinced Boaz to allow her to come under his protection (Ruth 3). Abigail dealt kindly with David, while also pleading forgiveness for her foolish husband (1 Sam. 25). Esther risked her life and intervened to direct her husband to the true threat in his kingdom (Est. 7).

These heroic women took chances and overcame difficult rulers and difficult circumstances, and they did so—only sometimes as wives to husbands—as the intelligent helpers God designed them to be.

## Pattern 4: Ungodly Women Influencing Men for Evil, Ungodly Men Mistreating Women

Let's try the same test in the opposite direction. Who are the most infamous women in the Old Testament—the ones renowned for their wickedness, the ones that our daughters don't get named after? Many of the most obvious names are those who deceived, disrespected, or misled their husbands. Think of Jezebel leading Ahab into greater and greater iniquity (1 Kings 21), Delilah tricking Samson (Judg. 16), or Michal rebuking David's exuberant worship (2 Sam. 5). Of course, these patterns are just that—patterns. [There are women in the Old Testament who make a name for themselves apart from men, but those are rare. Most of the positive and negative examples of women in the Old Testament are positive or negative based on how they influenced men for good or for evil.]

It also bears mentioning that some of the most well-known women in the Bible are well-known because of the way they were treated wickedly by men. One thinks of the sad stories of Dinah (Gen. 24), Bathsheba (2 Sam. 11), and Tamar (Gen. 38; 2 Sam. 13), or of Lot's daughters offered to the men of Sodom (Gen. 19), or Jephthah's daughter (Judg. 11), or of the Levite's concubine (Judg. 19). Men who abuse, malign, or mistreat women sin not just as human beings; they sin in violation of their calling as men. In our fallen world, should-be helpers can

become hindrances, and, even worse, should-be protectors can become oppressors.

## Pattern 5: Women Finding Pain and Purpose Associated with Bearing and Caring for Children

We saw in the creation account that Eve was a helper for Adam most fundamentally because she helped him fulfill the mandate to be fruitful and multiply—the one aspect of being an image bearer that the man could not accomplish himself. We also saw the woman experience the effects of the curse in her role as a mother. To be a woman is to be a womb-man, the type of human being with capacity to give birth to children (even if every individual woman may not have that physical ability or opportunity).

It's not surprising then that the pain (because of the fall) and purpose (because of God's design) of women is so often bound up in children. At almost every turning point in redemptive history we encounter a barren woman who is given power by God to conceive a child: Sarah with Isaac (Gen. 21:1–3), Rebekah with Esau and Jacob (Gen. 25:21–25), Rachel with Joseph (Gen. 30:22–24), Manoah's wife with Samson (Judg. 13:3–24), and Hannah with Samuel (1 Sam. 1:19–20). This pattern carries over in the New Testament with Elizabeth and John the Baptist (Luke 1:13) and in a different sort of divine intervention with Mary and Jesus (Matt. 1:18–25). By the same token, God punishes disobedience by closing the womb of Abimelech's house (Gen. 20:18) and of David's wife Michal (2 Sam. 6:23). Throughout the Old Testament, there are few things worse that can befall a people than barren women (Prov. 30:16–17) and few things as

joyous as women being able to bear children (Ex. 23:26; Deut. 7:12–14; Pss. 113:9; 127:3–5; 128:3).

To be sure, a woman's worth is not tied to the children she has or her ability to have any children at all. We see all sorts of ways women in the Old Testament serve God and save God's people from harm. And yet there is a unique God-given purpose that women find in bearing and caring for children.[2] Consider the opening chapters of Exodus. We think of Exodus as all about Moses, but before Moses bursts on the scene—and, in fact, in order for him to burst on the scene—we are introduced to several women. Shiphrah and Puah, the Hebrew midwives, allow Moses to live because of their bravery and ingenuity. Moses's mother does the hard but right thing and preserves Moses by sending him down the river. Miriam serves her baby brother by scheming a way to bring Moses back home for a time. And Pharaoh's daughter raised Moses as her own son.

In the opening pages of Exodus—this great narrative of God's paradigmatic redemptive work—the entire story has been moved forward by women, and specifically by women looking after children. Shiphrah, Puah, Jochabed, Miriam, Pharaoh's daughter—God used them all in mighty ways, in ways they couldn't fully understand at the time, all by simply loving children and protecting their little lives. And notice that only one of these women was the birth mother of the child at the center of the story. Women who, for any number of reasons, do not bear children of their own can still be "mothers in Israel." I'm not suggesting that working with children is all that women can or should do in life or in the church. But we should recognize the Old Testament pattern and celebrate that caring for children will be one of the main things—and one of the most amazing things—many women will do with their lives.

# 3

# Revolution and Repetition

## Jesus and the Gospels

YOU MAY HAVE HEARD the quip before: God made us in his own image, and, ever since, we have returned the favor by making him in ours. If that's true about how we tend to reshape God in our likeness, it's even truer about God's Son. We'd all like to think that Jesus saw the world the way we see the world, and that the way we conduct our lives is how Jesus lived his life. The functioning Christology for many Christians (and most non-Christians) is simple: Jesus was just like us.

This is especially true when it comes to Jesus's view of men and women. We have to be prepared to be surprised. Jesus never "put women in their place," but neither did he try to dislodge men from theirs. Jesus takes a back seat to no one in being pro-woman. And yet his being pro-woman never necessitated being anti-men or against sexual differentiation. It's remarkable to consider how

the author and perfecter of our faith boldly and nobly interacted with women in his own day and how he equipped men for leadership at the same time.

## A Revolutionary Ministry

Out of a cultural background that minimized the dignity of women and even depersonalized them, Jesus boldly affirmed their worth and gladly benefited from their vital ministry. He made the unusual practice of speaking freely to women, and in public no less (Luke 7:12–13; John 4:27; 8:10–11). He also frequently ministered to the needs of hurting women, such as Peter's mother-in-law (Mark 1:30–31), the woman bent over for eighteen years (Luke 13:10–17), the bleeding woman (Matt. 9:20–22), and the Syrophoenician woman (Mark 7:24–30).

Jesus not only ministered to women, he allowed women to minister to him. Women anointed Jesus, and he warmly received their service (Matt. 26:6–13; Luke 7:36–50). Some women helped Jesus's ministry financially (Luke 8:2–3), while others offered hospitality (Luke 10:40; John 12:2). A number of women—Mary Magdalene, Joanna, Susanna, Mary the mother of James and Joses, Salome, Mary and Martha—are mentioned by name in the Gospels, indicating their important place in Jesus's ministry. Many women were among Jesus's band of disciples. And most significantly, women were the first witnesses to the resurrection (Matt. 28:5–8; Mark 16:1–8; Luke 24:2–9; John 20:1–2).

Underlying Jesus's ministry was the radical assumption that women have enormous value and purpose. The clearest example is his mother, Mary, who is called highly favored in Luke 1:28. Moreover, Jesus used women as illustrations in his teaching,

mentioning the queen of the South (Matt. 12:42), the widow of Zarephath (Luke 4:26), women at the second coming (Matt. 24:1), and the woman in search of her lost coin (Luke 15:8–10). He held up the persistent widow as an example of prayerfulness (Luke 18:1–5) and the poor widow's offering as an example of generosity (Luke 21:1–4).

Jesus addressed women tenderly as "daughters of Abraham," placing them on the same spiritual plane as men (Luke 13:16). His teaching on divorce treated women as persons, not mere property (Matt. 5:32; 19:9), and his instruction about lust protected women from being treated as nothing more than objects of sexual desire (Matt. 5:28). And in a time where female learning was suspect, Jesus made a point to teach women on numerous occasions (Luke 10:38–42; 23:27–31; John 11:20–27). In short, Jesus honored women, valued them, respected them, gladly benefited from them, and included them in his ministry in meaningful ways.

## A Male Apostolate and a Manly Christ

Jesus's honorable treatment of women was consistent with God's original design for male leadership. In keeping with the creational pattern, Christ's revolutionary attitude toward women stopped short of including them in spheres of responsibility that were designed for men.

It won't do to say that Jesus was simply going along with the customs of the day. He had no problem breaking social taboos, which is why he mingled with tax collectors, ate without washing his hands, redefined the Sabbath, reinterpreted the temple, condemned the Pharisees, and even honored women! The fact is that while he overturned some Jewish interpretations (e.g., about

divorce, lust, retribution), Jesus never rejected teaching from the Old Testament (Matt. 5:17). Jesus honored women in a countercultural way without rejecting the fundamental principles and patterns he inherited from his Jewish–Old Testament background.

Some object to this reasoning by pointing out that Jesus also called only *Jewish* men to be apostles. By the same logic then, wouldn't only Jews be eligible for positions of leadership in the church? No. The Jewishness of the apostles is linked to a particular moment in salvation history, while their maleness is not. After Pentecost, the kingdom Jesus ushered in was no longer for the Jews alone. Gentiles such as Luke and Titus assumed positions of teaching and leadership. The first leaders of the church were Jews, because the Christian community grew out of Judaism. As the community grew to include Gentiles, so did the nucleus of leadership. Male leadership, on the other hand, was important from the beginning and remained consistent. When the disciples needed a successor to Judas, the apostles looked for a *man* who had been with them (Acts 1:21–22).

Finally, let us not forget the most obvious fact of all: Jesus was a man. This doesn't mean God is a man, the perennial "old man upstairs." And yet Jesus's maleness is not without significance. Like the (public) prophets, priests, and kings of old, Jesus was a man. Like the first Adam, Jesus was a man. As a new Moses and a new Israel, Jesus was a man. As the divine figure commissioned by the Ancient of Days, Jesus was a man. As a perfect lamb-like sacrifice, Jesus was a man. And when Jesus comes again as a conquering warrior and righteous judge, he will come as a man.

Jesus, of course, came to save men and women. But in coming as a man he literally embodied what true manliness was meant to

be—saving, protecting, rescuing, leading, teaching, and serving. So it makes sense that while Jesus honored women and empowered them for ministry, when it came to selecting those for positions of authority, he chose only men. There is no one more pro-woman than Jesus, and no one—by his example and in his very person— who did more to affirm true manhood either.

# 4

# Of Heads and Hair

## 1 Corinthians 11:2–16; 14:33–35

WE NOW COME, in this chapter and in the three chapters that follow, to the major exegetical sticking points. I encourage you to read through the passages first or to read each of these four chapters with your Bibles opened to the relevant passages. I also encourage you to study these verses with a simple acronym in mind: SCAN. The Bible is *sufficient* for life and godliness. The Bible is *clear* in all its big ideas. The Bible is *authoritative* in all that it claims. And the Bible is *necessary* in order to know God's will and God's ways. In other words, let's bring to our study of the Bible all that we know to be true about the Bible, trusting that God will help us understand what may at first seem cloudy and controversial.[1]

I am not going to go through these 1 Corinthians passages line by line. Instead, I want to look at the most difficult and

most debated sections (which happen to be where the payoff is when thinking about men and women). To that end, let me try to answer six key exegetical questions.

### Question 1: What does it mean that the husband is the head of his wife?

> I want you to understand that the head of every man is Christ, the head of a wife is her husband, and the head of Christ is God. (1 Cor.11:3)

Verse 3 outlines a series of overlapping relationships: "The head of every man is Christ, the head of a wife is her husband, and the head of Christ is God." Anyone familiar with the scholarship on this issue knows that the little word "head" (*kephale*) has killed a lot of trees. Scholars, using their expertise in Greek and the latest computer software, have gone back and forth in articles and books arguing whether *kephale* means "authority over" or "source" (like the head of a river is its source). Others have argued that the word means "prominent," "preeminent" or "foremost." In the end, the context suggests that *kephale* in verse 3 must have *something* to do with authority. Roy Ciampa and Brian Rosner are right:

> Even if by "head" Paul means "more prominent/preeminent partner" or (less likely) "one through whom the other exists," his language and the flow of the argument seem to reflect an assumed hierarchy through which glory and shame flow upward from those with lower status to those above them. In this context the word almost certainly refers to one with authority over the other.[2]

Furthermore, we have other examples in Paul's writings where *kephale* must mean something like "authority over." In Ephesians 1, Paul says that Christ has been seated at God's right hand in the heavenly places, far above all rule and authority and power and dominion, and all things have been placed under his feet, and he has been made head (*kephale*) over all things to the church (1:20–22). The context demands that *kephale* refer to Christ's authority over the church, not merely that the church has its origin in Christ. Likewise, in Ephesians 5 Paul says wives are to submit to their husbands, for the husband is the head of the wife even as Christ is the head of the church (5:22–23). [Citing the headship of the husband as a reason for the wife's submission makes little sense if headship implies only source or origin without any reference to male leadership.] *Kephale*, in at least these two instances in Ephesians, must mean "authority over." And there are no grammatical or contextual reasons to think that Paul is using *kephale* in a different way in 1 Corinthians 11.

Therefore, we should understand 1 Corinthians 11:3 as saying that Christ has authority over mankind; the husband has authority over his wife (the Greek words for man and woman are the same for husband and wife); and God has authority over Christ. Thus, we have male and female—equal and interdependent (11:11–12)—relating to one another within a differentiated order.

In previous years, some complementarians made too much of the fact that Paul relates the husband-wife relationship to the headship of God over Christ. To be sure, there *is* an important point to be made from the God-Christ parallel in verse 3—namely, that headship does not imply ontological inferiority. To

have authority over someone—to be head of another—is not inconsistent with equality of worth, honor, and essence. But even here we should be careful to note that there is an "economic" expression of the Son in view in verse 3 ("Christ"), not an immanent or ontological expression (e.g., "Son"). We should not use the Trinity "as our model" for the marriage relationship, both because it is not necessary for complementarianism to be true and because the metaphysical inner workings of the ineffable Trinity do not readily allow for easy lifestyle applications. In fact, it is striking how the New Testament often grounds ethical imperatives in the gospel (e.g., marriage as an outworking of Christ and the church), but never in the eternal "ordering" of God.

*If* we are talking about the economic Trinity—the activity of God and the work of the three persons in creation and redemption—we can certainly say that the Son acts from the Father, while the Father does not act from the Son. There is an eternal ordering (*taxis*) of the Trinity that finds expression in time. And yet the language of the eternal subordination of the Son is not the best language to describe this order, nor do we ever see in Nicene tradition that the persons of the Trinity are distinguished by a relationship of authority and submission. Traditionally, the way in which the persons of the Godhead have been distinguished—and technically, they are *distinct* (which suggests three *hypostases*) not *different* (which would suggest another *ousia*)—is not by roles or by eternal relations of authority and submission, but by paternity, filiation, and spiration. To put it another way, the Father is the Father (and not the Son or the Spirit), the Son is the Son (and not the Father or the Spirit),

and the Spirit is the Spirit (and not the Father or the Son) by virtue of the Father's unbegottenness as Father, the Son's generation from the Father, and the Spirit's procession from the Father and the Son.

All of that to say, we should be extremely cautious about making sweeping statements about the Trinity from verse 3. What we can say from verse 3—and this is all we really need to say—is that headship does not have to be harsh (for God is the head of Christ) and that to be under the headship of another does not have to be demeaning (for Christ is under the headship of God). As Calvin puts it, "Yet, inasmuch as he became a Mediator in order to bring us near to God, his Father, he is set beneath, not in that divine essence, which resides in him in all fullness, and in which he does not differ from his Father at all, but as to his making himself our Brother."[3]

## Question 2: What is the covering?

> Every wife who prays or prophesies with her head uncovered dishonors her head, since it is the same as if her head were shaven. (1 Cor. 11:5)

Some argue that the head covering in 1 Corinthians 11:5 is long hair. After all, doesn't verse 15 tell us that "her hair is given to her for a covering"? Long hair, though, is almost certainly not the covering itself. Verse 15 does not have to mean that long hair is given *instead* of a covering; it can mean simply that hair is given *as* a covering. The argument from verse 14 into 15 suggests that long hair is not the covering required in worship but is indicative of the fact that a covering *is* required (see also verse 6 where

an uncovered head is not identical to, but is as disgraceful as, a shaved head). Roman women in late antiquity were to be marked above all else by *pudicitia* (Latin for "modesty"), and for a mature woman to wear her hair unveiled was one of the chief signs of sexual immodesty.[4]

So what was the covering? One educated guess is that it was some type of shawl. More than likely, it was not a veil as we see in many Muslim countries, because face coverings were not common in Greco-Roman culture. The covering Paul has in mind was possibly a small wrap-around, scarf-like garment that could be placed on the head when praying and prophesying.

**Question 3: What "head" does the woman dishonor?**

Every wife who prays or prophesies with her head uncovered dishonors her head, since it is the same as if her head were shaven. (1 Cor. 11:5)

One of the difficulties in this section is that the word "head" is used throughout the passage with different, sometimes multiple, meanings. Thus, "every man who prays or prophesies with his head covered dishonors his head" (11:4) means that every man who covers his physical head dishonors his spiritual head, that is, Christ (11:3). And what about the woman? She too dishonors her spiritual head when her physical head is uncovered. The *head* she dishonors is, by extension, Christ, but most immediately her husband. The wife's actions reflect on her husband, because she is his glory (11:7; cf. Prov. 31:23).

The problem in Corinth likely involved men and women. We can see how a licentious, uncovered wife would bring shame

to her husband. But men may have also been to blame. In the early Roman imperial period, men often used the dress and look of their wives in an effort to seek status for themselves.[5] While it is unlikely that husbands wanted their wives to participate in worship unveiled, it's likely that men were seeking glory from their wives as much as some women may have been in danger of bringing shame to their husbands.

**Question 4: What does Paul mean by "authority"?**

> That is why a wife ought to have a symbol of authority on her head, because of the angels. (1 Cor. 11:10)

Most English translations speak of a "sign" or "symbol" of authority. Even though there is no word for "sign" or "symbol" in the Greek of 1 Corinthians 11:10, most commentators are agreed that Paul is not saying that the woman should have authority over her own head. That conclusion does not easily follow from the rest of Paul's argument. Instead, we are right to think that the head covering is the sign or symbol of authority.

But what kind of authority? Traditionally, interpreters understood verse 10 to be talking about a sign of the husband's authority over his wife. More recently, however, many argue that the head covering is a sign of the authority the wife has to pray or prophesy. I don't think the two interpretations are all that different. In both views, the wife must have a sign on her head that she has not thrown off her husband's authority if she is to pray or prophesy. In other words, the head covering functions as a sign of submission to her husband *and* as a sign that she is therefore able to pray or prophesy in the assembly.

~ *What?*

## Question 5: What does Paul mean by referring to "nature itself"?

Does not nature itself teach you that if a man wears long hair it is a disgrace for him. (1 Cor. 11:14)

Nature refers to more than majority opinion or the prevailing customs of the day. Paul uses "nature" to mean God's design or the way God has ordered things to be, for Gentiles sometimes "by nature do what the law requires" (Rom. 2:14). There is something transcultural in Paul's use of the word (see Romans 1:26 where Paul disparages homosexuality as contrary to nature). He uses nature as an appeal to the God-given sense of decency and propriety which remains even in our fallen world.

How then does nature teach us that women should have long hair and men's hair should be short? Men can grow as much hair as women, and Greek soldiers sometimes did. Samson was told not to cut his hair as part of a Nazirite vow (Judg. 13:5; see also Num. 6:1–12). So what is Paul getting at by his appeal to nature?

There is a curious mix—at least it seems curious to those of us twenty centuries removed from the original audience—of nature and first-century custom in Paul's argument. Nature doesn't teach us how long our hair should be. Culture teaches us the acceptable hair lengths for men and women. Nature, though, teaches us that men ought to adorn themselves like men and women like women. The natural God-given inclination of men and women is to be ashamed of that which confuses their sexual difference. Culture gives us the symbols of masculinity and femininity, while nature dictates that men should embrace their manhood and women embrace their womanhood.

*[handwritten margin notes: "What symbols?." / "Scripture should give us these 'culture' Not"]*

*Basically he says you should do it or not based off of Culture*

Should women still cover their heads while praying and prophesying? If that is your conviction, I would never tell you to go against your conscience, but I think Paul allows us to employ our own cultural cues of manhood and womanhood. It is impossible to know precisely what the head coverings were like. Being largely ignorant of the practice, any attempt at exact obedience would be more symbolic than actual.

More importantly, although Paul appeals to the created order in this passage, he stops short of explicitly grounding head coverings in God's original design. Because of the created order of the sexes, according to 1 Corinthians 11:10, the woman ought to have a sign of authority on her head. But notice that Paul doesn't give specific details as to the type of covering the woman should wear. Clearly he has in mind a head covering for the Corinthians, but what the creation order supports is not a certain kind of shawl but a symbol of authority. That's the key. When women pray and prophesy in the assembly, they must do so with some sign that signifies their authority to do so. In other words, something must tell the congregation, "This woman speaking in public is not throwing off her role as the glory of man. She is still in submission to her husband (if she has one), and therefore has authority to speak." Maybe this symbol is a wedding ring, or the way she dresses, or taking her husband's last name (in some cultures), or a well-known demeanor of gentleness and respect.

*But are they permitted to speak like that in Church?*

*where did He get that from?*

Paul's appeal to nature in verse 14 makes difficult an overly precise application of his foregoing principles. As has been argued, "the nature of things" teaches that long hair, as a cultural expression of femininity, is inappropriate for men. Nature does not instruct us on hair length, but it does teach us that in a culture

*Biblical*

*If this answer is based off of "culture" then what else can you say is based off your "culture"*

*nowhere in 1 Cor does it say 11:00 is referring to in Church*

where it is a symbol of femininity, long hair should be a disgrace to men. Nature teaches us that a woman should accept her role as a woman, but the expression of womanhood will be somewhat culturally conditioned.

I know this is all a bit vague, and some of us would like some hard and fast rules about hair length, but in this instance we are forced to live with some ambiguity. When a custom is good and decent, Calvin argues, we should accept it, but if we accept every cultural custom we will end up with a "hodgepodge of all confusion." The application of 1 Corinthians 11 calls for "prudence and discretion."[6] We can assert, without equivocation, that God wants men to look like men and women to look like women, but what that physically looks like will vary from time to time and place to place. Women may not have to wear head coverings, but they should demonstrate submission to their husbands and show proper expressions of femininity.

One final clarification: 1 Corinthians 11:16, "If anyone is inclined to be contentious, we have no such practice, nor do the churches of God," is sometimes used to disavow verses 2–15. The Greek word *toioutos* can mean "such" or "other." If it is "such," as the ESV renders it, we should understand Paul to be saying, "We have no such practice of being contentious," not "We have no such practice of wearing head coverings." If the word means "other," we should understand Paul to be saying, "We have no other practice in all the churches than what I laid out," not "We have no other practice of contentiousness, so do whatever you like." Verse 16 underscores the point that Paul's instructions do not come from personal preference but from what is good practice for the people of God everywhere.

## Question 6: How can Paul command women to be silent in the churches in 1 Corinthians 14 when he regulates women praying and prophesying in 1 Corinthians 11?

> The women should keep silent in the churches. For they are not permitted to speak, but should be in submission, as the Law also says. (1 Cor. 14:34)

In 1 Corinthians 11, Paul assumes that with the right symbols in place women can pray and prophesy in church (11:5). That Paul goes on in the rest of chapter 11 to give instructions for the Lord's Supper, and in chapters 12 and 14 to give instructions for the proper use of spiritual gifts in public, makes clear that Paul is thinking of the gathered assembly in 11:2–16. Women were not wholly silent in the Corinthian worship services. That's chapter 11. But then in chapter 14 Paul says, "The women should keep silent in the churches." So which is it—women can pray and prophesy or women must be silent?[7]

Some have resolved this dilemma by writing off Paul as hopelessly contradictory. Others treat 1 Corinthians 11 as hypothetical instructions—how women should adorn themselves if they *could* pray and prophesy, which, of course, they cannot. Still others see Paul as dealing with different contexts in the two chapters—chapter 11 dealing with informal gatherings where women may speak, and chapter 14 dealing with more formal church assemblies where women must be silent. And yet others imagine Paul is simply exaggerating in 1 Corinthians 14 because he has "had it up to here" with the chattering Corinthian women.

Let me suggest another alternative, one that is not at all unique to me: Paul allowed women to prophesy but did not allow them to join in the weighing of prophecy.

*If women could only speak to weigh Prophesy, + we dont prophesy anymore women should Remain Silent in almost all other areas.*

*$ says this piace evident prophesy today.*

The New Testament often speaks of prophets and prophecy (Acts 11:28; 13:1–2; 15:32; 1 Cor. 12:10; 13:2; 14:3; Eph. 2:20; 3:5; 4:11; 1 Tim. 1:18; 4:14; Rev. 11:6). If you are a continuationist who believes that all the gifts of the Spirit seen in the New Testament are operative today, you are probably convinced that New Testament prophecy was demonstrably different from Old Testament prophecy. If, however, you believe in the fundamental continuity between prophecy in the Old Testament and in the New Testament, then likely you are a cessationist, someone who believes that some of the Spirit's gifts in the New Testament were bound up with the era of the apostles. In both views, there is a desire to distance present-day congregational speech from the kind of "Thus saith the Lord" speech we find in Isaiah or Jeremiah. The difference is whether the speech as it exists today is a different kind of prophecy or something different from prophecy altogether. If prophecy died out with the apostles, then determining what women were allowed to do by way of prophesying in Corinth is less important. But even on this cessationist view (which I hold), 1 Corinthians 11 still speaks of women praying, so the question about speech (chapter 11) versus silence (chapter 14) is still relevant.

Whatever we make of New Testament prophecy in relationship to Old Testament prophecy, it is undoubtedly the case that teaching and prophecy in the early church were not identical kinds of speech. As we will see later, elders do not need the gift of prophecy, but they must be able to teach (1 Tim. 3:2). Likewise, the first pastors may or may not have been prophets, but they certainly were teachers (1 Tim. 4:11; 5:17; 6:2; 2 Tim. 2:2; Titus 1:9; 2:1–10). Teaching—passing on the apostolic deposit while

explaining and applying Scripture—was authoritative instruction in a way that prophecy was not.

This is not to suggest that prophecy did not play an important role in the church or that it did not convey a revelation from the Lord, but it had to be weighed and sifted (1 Thess. 5:20–21). If your view holds that New Testament prophecy was a fallible communication of infallible truth, then the "weighing" may have dealt with individual elements of the prophetic communication. If your view holds that New Testament prophecy was akin to Old Testament prophecy (Acts 11:27–29; 21:10–12; cf. 28:17), then the "weighing" dealt with true and false prophecies as a whole rather than with true or false elements. In either case, most commentators now agree that 1 Corinthians 14:34–35 is about sifting the words of the prophets, an activity that could include analyzing the life of the prophet and cross-examining the prophet's speech and conduct.[8] This kind of activity was out of bounds for women, who could very well end up interrogating their husband or someone else's husband. A wife cannot submit to her husband if she is asking him to submit to her judgment about his prophecy. Paul did not allow women to speak in this context but encouraged wives to ask their probing questions of their husbands at home.

All that to say, the command for women to be silent must be understood in context. Just as the command for the tongue speaker to keep silent does not forbid him from ever saying anything in church (14:28), so the command for women to be silent does not assume that in all situations women cannot speak. The explicit situation in which women must be silent is where prophecies are being evaluated. Such evaluation would have involved teaching and the exercise of authority (over other prophets), two

activities Paul consistently denies to women. If women have questions regarding the weighing of prophecies, they should ask their husbands at home, lest they violate the principle of submission and disgrace themselves (14:34–35).

What this means in practice today requires wisdom and contextual awareness. At the very least, churches that do not allow women to speak in church under any circumstances are contradicting the instructions of Scripture. As a pastor, I've happily included women in the worship service to share a testimony, give an announcement, or offer a prayer. Depending on the size and formality of the church, it may be easier to utilize the contributions of women (and nonordained men) in a small-group setting. I've also tried to be mindful of the way different elements in a worship service function in a given congregation. In my tradition, there is usually a long intercessory prayer conducted by one of the pastors. It would not be right in my context to have a woman give this prayer. But I have had women pray in worship services in more specific contexts or in less formal ways. As a general rule, I believe most complementarian pastors could do a better job finding biblically allowable ways to use women in church gatherings to pray, to relate a story of God's grace, or to share an encouraging word.

You cannot say the head covering passage should be based on cultural definitions of what is feminine. Scripture should make those.

# 5

# A Marriage Made in Heaven

## Ephesians 5:22–33

IN 2004, President George W. Bush nominated J. Leon Holmes to serve on the federal district court of Arkansas. Holmes became a controversial nominee when it was discovered that in 1997 he coauthored an article with his wife in the *Arkansas Catholic Review* in which they wrote, "The wife is to subordinate herself to the husband . . . the woman is to place herself under the authority of the man."[1] Holmes claimed that the words were taken out of context. Senator Dianne Feinstein opposed Holmes's nomination, asking, "How can I or any other American believe that one who truly believes a woman is subordinate to her spouse [can] interpret the Constitution fairly?" Republican senators Susan Collins, Lisa Murkowski, and Kay Bailey Hutchinson also demurred, arguing that Holmes did not have a "fundamental commitment to the equality of women in our society." Although Holmes was

eventually confirmed by the Senate 51–46, the objections raised by the Senate in the early 2000s are, no doubt, even more widespread today.

[It may sound archaic, if not fundamentally sinister, but God's design for the home is a thoughtful, intelligent, gentle, submissive wife and a loving, godly, self-sacrificing, leading husband. Whether we live in the first century or the twenty-first century, Ephesians 5:22–33 is God's good plan for marriage: wives, submit to your husbands; and husbands, love your wives.]

## Reversing the Curse

The first thing to notice from the text is how the overarching commands for husbands and wives are given at their specific point of fallenness. The commands to submit and love are intended to reverse the curse inflicted in the garden of Eden. God's plan from the beginning was for the wife to help and the husband to lead. But sin corrupted God's design.

According to Genesis 3:16, the marriage relationship after the fall became one of mutual struggle and frustration. The inclination of a sinful wife is to rebel against her husband's authority and try to control him. Paul's command aims to reverse the effects of the curse and have Christian wives submit rather than usurp.

Likewise, men, who are supposed to lead and protect and provide for their wives, now, tainted by sin, treat their wives harshly. The inclination of the sinful man is to exercise ungodly rule over his wife. Paul's command aims to reverse the effects of the curse and have Christian husbands love rather than domineer.

## The Submissive Wife

What does this look like in real life? How do Paul's commands in Ephesians 5 translate to life two thousand years later?

We could summarize the woman's responsibilities in marriage this way: *Wives, in submitting to their husbands, ought to support, respect, and follow them as to the Lord.* Let's look at this sentence in more detail.

Notice that last phrase "as to the Lord." The motivation for obedience to this command is Christ. Slaves are to obey their earthly masters as they would obey Christ (6:5). Children are to obey their parents in the Lord (6:1). And wives are to submit to their husbands as to the Lord (5:22). Submission is part of what it means to be a godly Christian wife, filled with the Spirit.

We must be careful though. "As to the Lord" does not mean wives should submit to their husbands in exactly the same way they obey Christ. Paul never calls wives servants of their husbands like he calls himself a servant or slave (*doulos*) of Christ (Rom. 1:1). Christ is the supreme absolute authority; all other authority is only derivative. So when Paul says wives should submit to their husbands in everything (5:24), we must let Scripture interpret Scripture. The "in everything"  does not overturn all the other commands in Ephesians. Wives should not steal, brawl, slander, and indulge in every kind of impurity just because their husbands say so. The husband's authority does not trump the authority of Christ. In submitting to husbands, obeying parents, obeying masters, and obeying governing authorities, we do not obey to the point of disobeying God (Acts 5:29).

But we should not make Paul say the opposite of what he actually says. He *does* command submission, and not on the basis of shifting cultural sand, not even on the basis of the husband's love. He roots the command in two unchanging theological principles. First, the husband is the head of the wife. And, second, "as the church submits to Christ, so also wives should submit in everything to their husbands" (Eph. 5:24). Because of these two realities—the headship of the husband in the created order and the analogy of Christ and the church—the wife should freely submit to her husband.

And don't miss that word *freely*. The command is for the wife, not the husband. The man is never told to submit the wife unto himself. Instead, the woman is told to submit herself unto her husband. It is a submission freely given, never forcibly taken.

## Submission in Real Life

Let's look again at the summary sentence for the woman's responsibility: In submitting to their husbands, wives ought to support, respect, and follow them as to the Lord. I use three verbs to describe freely given submission: *support, respect,* and *follow.* Let me put my pastor hat on for a moment and speak directly to wives with each of these words.

Wives, *support* your husbands. God made you to be a helper for your husband (Gen. 2:18). Do what you can to encourage him as a husband, father, and worker. Come alongside him, not to control him or to be recognized for your service (but your husband should recognize it), but to help him. I think it is fitting, in most situations, that the wife let her husband's vocation take priority over her own. I know that is not a popular thing to say. But I think it is a fair application of what it means to be a helpmate. When a couple can-

not figure how to make both of their careers a go, I think the wife should be willing to say, "I want to be a help and support to you."

Wives, *respect* your husbands. A man may get built up or torn down at work, but the words that can really make him or break him are the ones from his wife. Give your husbands unconditional respect (which is not the same as unconditionally enduring mistreatment) just as your husband ought to show you unconditional love. "Let each one of you love his wife as himself, and let the wife see that she respects her husband" (Eph. 5:33). The husband should love his wife regardless of how lovely she is, because she is as the church to him. And the wife ought to respect her husband regardless of how worthy of respect he is, because he is as Christ to her. Consider the way holy women of the past put their hope in God to make themselves beautiful. They were submissive to their husbands, like Sarah, who obeyed Abraham and called him her lord (1 Pet. 3:5–6). In our culture it would be strange to call your husband "lord," but if you want to be truly beautiful, your attitude toward your husband will be like Sarah's to Abraham.

And wives, *follow* your husbands. Respond to his initiative. Don't second-guess him all the time. You can certainly have an opinion and should not be afraid to voice it, but don't try to undermine his properly exercised authority. Provided he's not sinning against you or leading you into sin, follow him.

I'm thinking especially of following your husband as a spiritual leader. I could use my wife for all sorts of positive examples in this chapter, but especially in this area I feel so fortunate. I cannot remember my wife ever refusing me, or even being put off, when I suggest we pray or sing a hymn or read a book together or work our way through the Bible or go to church. What a blessing to

have a wife who gladly follows my stumbling attempts at spiritual leadership.

Trisha and I have our little squabbles like every other couple. But I have always sensed her respect for me. I feel immeasurably blessed to have a wife who is willing to follow in the most gracious, intelligent, strong, but gentle way possible. Three times I have moved our family from places we loved, surrounded by friends and familiarity, to places that were strange and unknown, especially to my wife. And every time—when we moved from Massachusetts to Iowa, from Iowa to Michigan, and from Michigan to North Carolina—my wife was terribly sad to leave (so was I). Every time, we talked and prayed a lot together. And every time, when it came down to making a decision, my wife, in effect, told me, "Kevin, you know I don't want to leave, but you know that I will be okay with whatever you decide." What pain it would have brought us both if my wife's attitude had been, "I'm not going to the middle of nowhere. I don't want to be around that much snow. I'm not leaving my friends." But instead she honored and respected and followed me better than I deserve.

### The Loving Husband

What about the men? What does Paul have to say to them? We could summarize the man's responsibilities in marriage this way: *Husbands, in loving your wives, lead, sacrifice, and care for them as Christ does for the church.*

Let's start with the last phrase again—"as Christ does for the church." The motivation for love is, well, love. The wife is to submit to her husband because he is, in certain ways, as Christ to her. And the husband is to love his wife for the same reason, because

he is, in certain ways, as Christ to her. Men, your number-one command in marriage is to love like Jesus. As Presbyterian pastor and American founder John Witherspoon said 250 years ago, "If superiority and authority be given to the man, it should be used with so much gentleness and love as to make it a state of as great equality as possible."[2]

The verb *love*, like the verb *submit*, is given, not taken. The wife does not manipulate or demand love from her husband. The husband freely and unconditionally shows love to his wife. In both commands—submit and love—the focus is on what we give, not on what we get. The problem with so many books on marriage is that they focus on what we need to get out of marriage instead of telling us what we need to give in marriage. I have read Christian marriage books that do nothing but appeal to self-interest. They give us great insight on how to be loved, how our needs can be met, how our love tanks can be filled. While these books may have some fine commonsense insights, the basic philosophy is, "I'll scratch your back, because then you'll scratch mine." The mindset is love in order to be loved. But Jesus says, "If you love those who love you, what reward do you have? Do not even the tax collectors do the same?" (Matt. 5:46). The Christian approach to marriage is not so much "his needs, her needs" as "his opportunity to honor Christ, her opportunity to honor Christ." The wife submits as to the Lord, and the husband loves as Christ to the church.

### Love in Real Life

So, once again, what does this look like? Earlier I used three verbs to describe freely given love: *lead*, *sacrifice*, and *care*. Let me again speak directly to the men with each of these words.

Husbands, *lead* your wives. I remember hearing John Piper say on more than one occasion that the husband should be the one who most often says, "let's." That simple piece of advice has always stuck with me. "Honey, let's go on a walk." "Let's pray together." "Let's get the kids ready for bed." Take the initiative, men. This isn't about making every decision or believing that listening to your wife is a sign of weakness. Again, John Witherspoon puts it well: "I therefore take the liberty of rescuing from the number of hen-peckt, those who ask the advice, and follow the direction of their wives in most cases, because they are really better than any they could give themselves."[3] Good leaders sometimes follow, and insightful followers sometimes are given the opportunity to lead. The point about "let's" is the man's posture, his eagerness to make plans, take risks, and be fully engaged in the marital relationship.

This is especially true when it comes to spiritual leadership. Christian husbands can be aggressive and assertive when it comes to making money, tackling problems at work, or pursuing their hobbies, but when it comes to loving leadership in the home, too often they're doormats. They take zero responsibility for the spiritual well-being of their household.

And yet God holds men accountable for the spiritual welfare of their wives. "Love your wives, as Christ loved the church and gave himself up for her, that he might sanctify her, having cleansed her by the washing of water with the word, so that he might present the church to himself in splendor, without spot or wrinkle or any such thing, that she might be holy and without blemish" (Eph. 5:25–27). I have a responsibility for my wife's holiness. Trisha's marriage to me should be an instrument of edification, purification, and sanctification.

Being a spiritual leader means taking the initiative to repair the breach when the relationship has been damaged. If Christ loves the church, his wayward bride, and continually woos her back from her spiritual adulteries, how much more should you woo back your wife after a disagreement when half the time it will be your fault anyway? It is always 100 percent the church's fault. And it is never 100 percent your wife's fault. Husbands ought to take the first step toward reconciliation when the marriage has grown cold with hurts and disappointments.

Husbands, *sacrifice* for your wives. Perhaps the most important thing for your marriage is that you understand the doctrine of the atonement. Jesus died for the church. Your leadership as a husband is a self-sacrificing leadership.

This can mean little things: coming home early, taking care of the kids, participating joyfully in something she likes to do, overlooking an offense, running errands, fixing something around the house, cleaning up the house. Loving your wife can also entail bigger sacrifices. You may need to forfeit climbing the corporate ladder in order to be a decent husband. You may be called upon to give up your hopes and dreams in order to take care of your wife after she falls ill or is injured. You may sacrifice the big house or the best neighborhood and live at a lower lifestyle so your wife can stay home with the kids. Chrysostom was right as he exhorted husbands to lay down their lives for their wives: "Yea, even if it shall be needful for thee to give thy life for her, yea, and to be cut into pieces ten thousand times, yea, and to endure and undergo any suffering whatever,—refuse it not. Though thou shouldest undergo all this, yet wilt thou not, no not even then, have done anything like Christ."[4]

Finally, husbands, *care* for your wives. Cherish her as your own body (Eph. 5:28). She is not merely your partner. She is your other half, your own flesh and bone. You don't abuse your body; you build up, protect, and nourish it. Likewise, cherish and care for your wife. "Husbands, love your wives, and do not be harsh with them" (Col. 3:19). You should just as easily treat your wife harshly as you should punch yourself in the face. "The man who does not love his wife," Calvin says, "is a monster."[5] Take care of her needs for food, clothing, and security. There is no law which says the wife cannot make more than the husband, but there is this command for husbands to feed and care for their wives.

Your wife should feel secure in your provision and protection of her. As Edgar Rice Burroughs wrote in *Tarzan of the Apes* when the title character first saw Jane Porter, "He knew that she was created to be protected, and that he was created to protect her."[6] Such a sentiment will strike many today as quaint, if not outright sexist. But there are worse things than men feeling deep within themselves that women are to be protected, not exploited, defended, not demeaned, and treated with special honor instead of nothing special whatsoever. In fact, Mary Eberstadt argues that the sexual revolution—with its laissez-faire attitude toward sex and its insistence that men and women are the same when it comes to sex—has left women vulnerable and frustrated. "The furious, swaggering, foul-mouthed rhetoric of feminism promises women what many can't find elsewhere: *protection*."[7] Women, more than ever, need to know that men *will* treat them by a different set of rules and will seek the well-being of women above their own.

Maybe there is something right in all those chivalry stories about the man fighting for the honor of the woman, defending

her to the last, treating her like a queen. In the book *A Return to Modesty*, Jewish author Wendy Shalit comments on the quaint etiquette rules from the past—rules like "a man always opens a door for a woman," or "a man carries packages or suitcases for a woman," or "a man rises when a woman comes into the room," or "if a woman drops her glove in the street, you'd certainly pick it up," or you never "race a woman, young or old, for a vacant seat." Shalit acknowledges that "one can certainly criticize these rules as sexist, and many have." But she continues, "The simple fact is that a man who observed all of the above rules was a man who treated a woman with respect, a man who was incapable of being boorish." Women were not to be treated like men; they were to be treated differently, like women. Consequently, "in the old view, if you weren't considerate to women, you weren't really a man."[8]

If men in general ought to treat women with special care and kindness, how much more so for our own wives. D. L. Moody once remarked, "If I wanted to find out whether a man was a Christian, I wouldn't ask his minister. I would go and ask his wife. . . . If a man doesn't treat his wife right, I don't want to hear him talk about Christianity."[9] Would you feel comfortable putting your wife down as a reference on your Christian resume? Throw out all the ways our culture confuses love with feelings and euphoria; could your wife look you in the eye and say with all sincerity and tenderness, "Honey, you love me well, like Christ does the church"?

### The End of the Matter: God's Glory

And so I end where this passage, Ephesians 5:22–33, ends, with the analogy between Christ and the church. If wives do not submit

to their husbands as to the Lord, and husbands do not love their wives as Christ loved the church and gave himself up for her, how does the analogy work in verse 32? Marriage is a picture of Christ and the church. If there is no distinction in how we related to each, no ordering, no self-sacrificing headship, no joyful submission, we are left with Christ and Christ or the church and the church.

God is trying to show something in our marriages. If we disallow sexual differentiation, we are not allowing to shine forth the very heart of marriage itself. Yes, God created marriage for companionship and for sex and for children, but most of all, he created marriage to reveal this profound mystery of Christ and the church. This is a high calling. His plan is for a watching world to look at husband and wife and see such gentle, joyful submission and such self-denying, loving leadership that it gets a picture of the beauty that is the relationship between Christ and his church. Nothing less than God's full glory is at stake.

# The Heart of the Matter

## 1 Timothy 2:8–15

BECAUSE THIS SECTION from 1 Timothy is in many ways the heart of the matter, and literally almost every word is in dispute, I will move methodically through this passage, giving a verse-by-verse exposition.

## Context

Timothy's location at Ephesus is thought by some to be highly significant. Some scholars claim that Ephesus was a hotbed for radical feminism, that the cult of the goddess Artemis typified the feminist principle that saturated first-century Ephesus. With this as the perceived background, it is then argued that the situation in 1 Timothy is unique and that Paul's commands are limited to the extreme feminism rampant in the immediate culture.

The problem with this reconstruction is that it is more fiction than fact. Ephesus was a fairly typical Greco-Roman city.[1] The political, cultural, and religious elements were not out of the ordinary. Like in other ancient cities, the magistrates of Ephesus were male. Likewise, the civic groups in Ephesus were dominated by men. The religious climate was, not surprisingly, polytheistic. Temples and houses throughout the city boasted any number of gods and goddesses. And even though priestesses were common in Greek cities, most of the deities in Ephesus were served by priests.

True, Ephesus was famous as the city of the goddess Artemis (Acts 19:35), and no doubt women participated in the cultic rituals along with men. But the description of Artemis of the Ephesians in Acts 19 tells us nothing that would make us think there was a proto-feminist ethos surrounding Timothy's congregation. In fact, all the main characters mentioned by Luke are men: Demetrius, who made silver shrines of Artemis, was a man (19:24), and he addressed the crowd as "men" (19:25; cf. 19:35); the Asiarchs (high-ranking officers of the province) would have been men (19:31); the city clerk would have been a man as well (19:35). The biblical depiction of Ephesus gives no indication that men were not in charge of the resources and religious activities in the temple of Artemis, as they were in the religious centers all throughout the ancient world.

Ephesus simply was not a radically feminist place. Privileged women of the city were praised for their modesty and devotion to their husbands. The roles—both good and bad—that women filled in Ephesus were no different from the roles women filled in other ancient cities: wives, mothers, farmers,

home managers, prostitutes, and fortune-tellers. This is not to suggest that Ephesus was especially harsh toward women. It is only to say that in terms of gender roles, first-century Ephesus was unremarkable.

Besides, whatever Ephesus was like, we should not think that Paul's focus in 1 Timothy is especially narrow. He writes so that "you may know how one ought to behave in the household of God, which is the church of the living God" (1 Tim. 3:15). To be sure, every piece of writing is conditioned by its recipients. Yet while Paul addresses specific problems (as he does in all his letters), he never suggests that the principles set forth are culturally limited. Rather, as 1 Timothy 3:15 indicates, Paul is concerned more broadly with how believers conduct themselves in God's household, wherever it may be.

Paul begins this section on worship instructions by addressing men:

> I desire then that in every place the men should pray, lifting holy hands without anger or quarreling. (1 Tim. 2:8)

The men are to lift up their hands in prayer. The emphasis, though, is not on posture. Prayer in the Bible is sometimes standing, sometimes kneeling, sometimes lying prostrate (1 Kings 8:54; Ps. 95:6; Dan. 6:10; Matt. 26:39; Luke 22:41; Acts 9:40; Rev. 11:16). Posture is not the point; piety is. Men should pray with *holy* hands, *without anger or quarreling*. Paul's instructions move inward, from appearance in prayer to attitude in prayer.

Paul now shifts his focus and addresses the women. He commands women to dress modestly and then adds three clarifying clauses:

> Likewise also that women should adorn themselves in respect-
> able apparel, with modesty and self-control, not with braided
> hair and gold or pearls or costly attire, but with what is proper
> for women who profess godliness—with good works. (1 Tim.
> 2:9–10)

First, women are to dress with modesty and self-control. There should be a sense of propriety, moderation, and a refraining from sensuality. Second, women are to dress not with braided hair or gold or pearls or expensive clothes. Such items flaunted wealth and drew attention to external beauty rather than to "the imperishable beauty of a gentle and quiet spirit" (1 Pet. 3:4). Third, women are to dress with good works. As with the men, Paul moves inward, from appearance to attitude. His main concern is that women adorn themselves in a manner fitting the gospel.

These two verses, 1 Timothy 2:9–10, have been used to negate whatever else Paul commands of women in the rest of 1 Timothy 2. If braided hair is cultural, so the argument goes, then the other commands for women must be as well. But the prohibition regarding braided hair and the like is far from Paul's main point. It only clarifies how women are to dress modestly. Paul's focus is on internal maturity and its accompanying external modesty. Braided hair, gold, pearls, and expensive clothes are not intrinsic evils. Heaven is full of gold and pearls (Rev. 21:18–21), and the Old Testament priestly garments were expensive and ornate (Ex. 28). The problem with these items is their abuse.

This is confirmed by the similar passage in 1 Peter 3:3–4. Women are commanded, "Do not let your adorning be external—

the braiding of hair, and the putting on of gold jewelry, or the clothing you wear—but let your adorning be the hidden person of the heart." Literally, Peter did not condemn a certain kind of clothing, just clothing itself. Yet, clearly, women do not have to go to church without any clothes on whatsoever (not the point about modesty Peter is trying to make!). Dress is not the fundamental problem, even though that's literally what Peter mentions. The issue arises when the putting on of clothes (or the wearing of pearls and gold and braids) becomes sensual or showy. Peter's concern, like Paul's in 1 Timothy, is that women labor to make themselves beautiful on the inside, not on the outside.

Paul continues:

Let a woman learn quietly with all submissiveness. (1 Tim. 2:11)

First off, it must be said that Paul is saying something countercultural by commanding women to learn. Some segments of Judaism considered it downright sinful for women to learn the Scriptures. Paul disagreed. He was eager for women to learn, provided they did so in quietness and full submission.

*Quietness* or *silence* (2:12) is not meant to be demeaning. Both are positive qualities for the learner (see Eccles. 9:17). And as we've seen from 1 Corinthians 11 and 14, silence is not an absolute command encompassing every element of corporate worship. Silence, in this text as well as 1 Corinthians 14, refers to the teaching ministry of the church. In the context of corporate worship, women are not to be teachers, but quiet learners.

"All submissiveness" clarifies why women are expected to be quiet. They are to cultivate a spirit of submissiveness, specifically a

wife to her husband (Eph. 5:22; Col. 3:18; Titus 2:5; 1 Pet. 3:1). In short, a woman who learns quietly embraces her submissive role and honors God's design for the sexes.

> I do not permit a woman to teach or to exercise authority over a man; rather, she is to remain quiet. (1 Tim. 2:12)

Verses 11 and 12 form a single unit. The central idea—women should be silent—bookends the unit. Thus, the command for quietness and submission begins verse 11, and the command for silence finishes verse 12. In the middle we have an explanation of what it means for women to learn in quietness and full submission. Women should not teach (respecting the command for quietness) and should not have authority over a man (respecting the command for all submissiveness).

### "I do not permit . . ."

Some argue that since the verb "permit" (*epitrepo*) is in the present tense we should really understand Paul as saying, "I am not presently allowing a woman to teach," the implication being, "but I may allow a woman to teach at another time." But this is an unreasonable understanding of grammar. If present-tense verbs carry weight only for the time in which they were written, much of the New Testament has no significance for us whatsoever. In the Pastoral Epistles alone, there are 111 present-tense verbs like "permit" here in verse 12. If these verbs do not extend beyond Paul's initial audience, then God no longer "desires all people to be saved" (1 Tim. 2:4), the "mystery of godliness" is no longer great (1 Tim. 3:16), and there is no "great gain" in godliness with contentment (1 Tim. 6:6).

*"a woman to teach . . ."*

Some have argued that Paul is only commanding women to avoid teaching error (she was unlearned, right?), but other kinds of teaching are permissible. This reasoning sounds plausible but will not work.

First, the verse doesn't say anything about teaching error or women being unlearned; it simply says, "I do not permit a woman to teach." Besides, how ignorant could the Ephesian women be if Paul taught among them day and night for three years (Acts 20:31)?

Second, Paul does not use the word for false teaching (*heterodidaskaleo*) as he does in 1 Timothy 1:3 and 6:3. He uses the word "teaching" (*didaskein*). Except in Titus 1:11, where the context absolutely demands false teaching, *didaskein* in the Pastoral Epistles is used in a positive sense of teaching the truth of the gospel or the apostolic message (see 1 Tim. 4:11; 6:2; 2 Tim. 2:2).

Third, why would Paul prohibit women, but not men, from teaching error, especially when the false teachers mentioned by name in the Pastoral Epistles are all men (Phygelus, Hermogenes, Hymenaeus, Philetus, Demas, and Alexander the metalworker)?

*"or to exercise authority over a man . . ."*

There is considerable debate over the meaning of the word "authority" (*authentein*, which is the infinitive form of the verb *authenteo*). Some scholars suggest that *authentein* should be translated "to domineer," which is the sense one gets from the King James Version: "to usurp authority." If *authentein* means "to domineer" or "assume authority" (NIV), then Paul may not

be prohibiting women from having authority but simply from getting it improperly. This would change the meaning of the text significantly.

A more likely translation, however, is simply "authority" (as per the NIV [1984], NASB, NLT, ESV, RSV, and NRSV). This is the best translation based on the following considerations.

First, it would be strange for Paul to warn women against domineering, but not men, given that he is writing to a man and the false teachers we know of were men (see the list above).

Second, teaching and authority are so closely linked in this verse that both must be either positive or negative. The phrase "I do not permit a woman to teach or to exercise authority" is, to put it syntactically, (1) a negated finite verb + (2) infinitive + (3) *oude* (not/nor) + infinitive + (4) *alla* (but) + infinitive. Recent studies have shown that when this pattern is used in the New Testament (Acts 16:21), or when a similar pattern is employed in the rest of the New Testament without verbal infinitives (another forty-two passages), the two activities or concepts are either both positive or both negative.[2] So Paul is either forbidding women from teaching error and domineering, or he is forbidding them from teaching and having authority over men altogether. The latter is the case because (1) *didaskein* is almost always used positively in the Pastoral Epistles, (2) there is no object after *didaskein* (such as "error" or "falsehood"), and (3) 1 Timothy 2:13–14, which gives Paul's reasons for the command (verse 13 especially), would be unnecessary if he were forbidding only teaching error and domineering.

Third, where *authenteo* is used outside of the New Testament (it's only used in the New Testament in this verse), it does not

mean "to domineer" or "usurp authority." It can mean to rule, to control, to act independently, or to be responsible, but it does not carry the negative sense "to usurp" or "domineer." The word is used in different ways, but the unifying concept is that of authority understood in a neutral or positive sense.[3]

In the end, the best option is to see "no teaching" and "no authority over a man" as the explanation of what it means for a woman to learn in quietness (without teaching) and full submission (without authority over men). Thus, verse 12 could be summarized: "God desires women to be silent and submissive in the church, which means that women should not be public teachers over men nor exercise authority over men." Two commands are in view, not just one. To put it another way, Paul is not just opposed to authoritative teaching (where nonauthoritative teaching could be permissible?). He prohibits women doing two different, but related things, in the church: teaching over men and exercising authority over men.

After stating the principle ("Let a woman learn quietly with all submissiveness") and further explaining it ("I do not permit a woman to teach or to exercise authority over a man"), Paul now backs up his argument with two reasons:

> For Adam was formed first, then Eve; and Adam was not deceived, but the woman was deceived and became a transgressor.
> (1 Tim. 2:13–14)

The word "for" (*gar*) tips us off that Paul is now giving us his reasons for verses 11 and 12. In the New Testament, *gar* most often expresses cause or reason. Thirty-three times it is used in the Pastoral Epistles; thirty times expressing cause. Despite this

fact, some scholars prefer to see "for" in verse 13 as illustrative rather than causal. That is, they understand Paul to be giving an illustration of his principle instead of giving reasons for it. To be fair, it is grammatically possible that Paul's use of "for" in verse 13 is only illustrative, but the fact that Paul is issuing a command (given negatively as "I do not permit") makes such usage highly unlikely. Nine times in his letters Paul gives an imperative command followed with *gar*, and in every instance *gar* functions in a causal sense. In the Pastoral Epistles, Paul issues a command or a command-idea (like "I do not permit") followed by *gar* twenty-one times, all of which require the causal sense. It is best, therefore, to keep the normal sense of *gar* and see "for" in verse 13 as introducing Paul's reasons for verses 11 and 12.

*Reason 1: Order of Creation*

For Adam was formed first, then Eve. (1 Tim. 2:13)

The first reason why women are not to teach or have authority is based on the order of creation. Adam was formed first, then Eve. Some object, "What about animals then? They were created before Adam, so why don't they have priority?" But this misses Paul's point. He is not making a definitive statement that applies to every bit of the sequence of creation. His thinking is perfectly consistent with the Old Testament idea of the firstborn. The firstborn was accorded special rights because he was the firstborn son in the family, regardless of whether animals had been born in the household or not. The order is also significant because it indicates Adam's position as the one who names, tames, and protects, and Eve's position as one who nurtures, helps, and supports.

*Reason 2: Eve Was Deceived*

And Adam was not deceived, but the woman was deceived and became a transgressor. (1 Tim. 2:14)

First Timothy 2:14 can be interpreted in one of two ways. Paul may be making a statement about the nature of women; namely, that they are more easily deceived than men. This understanding does not say that women are inferior to men or less capable of piety than men. Rather, according to this interpretation, women and men have different inclinations that render them liable to different temptations. Men, who are generally more aggressive and assertive, may be on the whole more particularly tempted to harshness or schism. Women, who are generally more contextual and sensitive to the feelings of others, may be on the whole more particularly tempted to doctrinal deception. If Eve's deception speaks to the nature of women, then Paul forbids teaching or authority because women—who outshine men in other areas—are, on the whole, more likely to acquiesce to doctrinal deviation.

There is, however, another understanding of verse 14. Paul may be making a statement about what happens when the roles of men and women are reversed. Adam was supposed to be the head, responsible for loving leadership and direction. But he abdicated his role, and Eve's leadership influenced him for evil. As a result of this role reversal, sin entered into the world. On this understanding, Paul is pointing to the difference between the two guilty persons: Adam sinned openly, but Eve was deceived. In highlighting this difference, Paul may be grounding his argument in God's design for men and women, which was tragically supplanted in the fall.

No matter our understanding of verse 14, it should be obvious that Paul does not ground the silence and submission of women in first-century culture. In fact, he does precisely the opposite. His rationale for role distinctions in the church harkens back to Genesis. Paul does not permit a woman to teach or exercise authority over a man because to do so would be a violation of God's original design for the sexes in the created order, where the man was given headship and the woman was given to be his helpmate.

## Embracing God's Design

> Yet she will be saved through childbearing—if they continue in faith and love and holiness, with self-control. (1 Tim. 2:15)

This difficult verse is usually understood in one of two ways. Some see verse 15 as a reference to Mary. Through the virgin birth, the Messiah entered the world, and subsequently women (and men) were saved. This interpretation is plausible. Paul, having already alluded to the opening chapters of Genesis, could be thinking of Genesis 3:15, which prophesied that the seed of the woman would crush Satan. If so, the definite article ("the") before childbearing (in the Greek but not in most English translations) would be emphasized. Women are not saved through childbearing, but through *the* childbirth, the birth of Jesus.

There is a second common interpretation, one that, in my opinion, has more merit. If we understand that "salvation" in the New Testament does not necessarily mean justification, we can make more sense of the verse. Most of us read "salvation" and think of giving our lives to Christ and *getting saved*. But salvation has a much broader scope in the New Testament, covering the entire

life of the Christian, not just a single definitive moment of faith and repentance. Elsewhere, we are commanded to work out our salvation with fear and trembling (Phil. 2:12), not as meriting favor with God, but as a striving for Christian obedience. This is the sense of salvation Paul has in mind when he says that women will be saved through childbearing.

[Giving birth is one of the ways in which a woman demonstrates obedience to her God-given identity. Instead of casting off all order and decency, a godly woman embraces her true femininity in dressing modestly, learning quietly, bearing children, and continuing in faith, love, and holiness. Understandably, some women will not have children because of medical reasons or singleness, but in so far as it is possible, childbearing is one of the unique ways in which a woman can accept, in obedience, her God-given design.]

We will get to some application in the next chapter. Notice, for now, the underlying principles. In these eight controversial verses (1 Tim. 2:8–15) we see how manhood and womanhood work out in the church. Just as in the home, husbands should love their wives and not be harsh with them (Col. 3:19), so in the church, men should lift holy hands in prayer, without anger or disputing (1 Tim. 2:8). And just as wives are submissive to their husbands in the home (Col. 3:18), so in God's household women ought to learn in quietness and full submission, refraining from teaching or having authority over men (1 Tim. 2:11–12). Rather, as women embrace God's design, adorning themselves with modesty and conducting themselves with propriety, they will be working out their salvation, even as God works in them "both to will and to work for his good pleasure" (Phil. 2:13).

7

# Leaders, Servants, and Life Together

## 1 Timothy 3:1–13

THIS IS PROBABLY A GOOD PLACE to take a step back and say a word about polity (governance) in the early church. The New Testament knows two distinct church offices, given in 1 Timothy as overseers (3:1) and deacons (3:8). An earlier mention of these two offices is made in Paul's letter to the Philippians: "Paul and Timothy, servants of Christ Jesus, To all the saints in Christ Jesus who are at Philippi, with the overseers and deacons" (Phil. 1:1). Already by the late 50s or early 60s AD, the church was sufficiently organized to have the two offices of elder and deacon.

Notice that I am equating the "elder" in 1 Timothy 3 with the "overseer" of Philippians 1. I use the two terms interchangeably because of Acts 20. There are three Greek words used throughout

the New Testament to describe the spiritual leaders in the church, all of which appear in Acts 20. The first word is *episkopos*, sometimes translated "bishop," usually translated "overseer." The second word is *presbyteros*, translated "elder" or "presbyter." The third word is *poimen*, translated "shepherd" or "pastor." These three words—overseer, elder, pastor—refer to the same office. In Acts 20:17, Paul calls for the elders of the church to come to him before he leaves Ephesus. The word for elder in verse 17 is *presbyteros*. Then in Acts 20:28, while Paul is addressing the elders (the *presbyteros*), he commands them to keep watch over the flock (*poimainein*) as overseers (*episkopos*) and to care for, or pastor (*poimen* in its verb form), the church of God.

Notice how these spiritual leaders are called, interchangeably: elders, overseers, and pastors. The three words mean the same thing. In the New Testament, we don't see pastors and bishops above them, or elders and pastors above them. We see two offices in the church: overseer-pastor-elder and deacon.

These two offices serve two different functions, as anticipated in Acts 6:1–7. This passage does not mention by name elders or deacons, but remember we are only in Acts 6. The church is not yet at this point organized in terms of office and structure. But what we see here are the beginnings of the two offices of the church and their two main functions. Elders carry out the ministry of the word; deacons carry out the ministry of mercy.

Elders should be students of the Bible and men of exemplary character. They will be spiritual leaders. An elder must be able to teach (1 Tim. 3:2), something not required of deacons. Teaching does not have to mean lecturing in a classroom or giving a sermon, but it does mean that elders must know their Bibles,

know theology, be able to discern truth from error, and know how to communicate it to others. Titus 1:9 says about an elder: "He must hold firm to the trustworthy word as taught, so that he may be able to give instruction in sound doctrine and also to rebuke those who contradict it." Elders minister the word. That is their number-one priority.

Deacons, on the other hand, will be, first and foremost, servants. The Greek word *diakonos* means servant. Thus, deacons serve food and water. They distribute charity to and from the congregation. They serve the church body in physical ways. Elders provide spiritual bread; deacons offer physical bread. Elders give ministry oversight; deacons provide daily service. The ministry and giftedness of the entire church can be summarized as word and deed (Rom. 15:18; Col. 3:17; 1 Pet. 4:10–11), so it is no surprise that the officers of the church reflect this basic demarcation: elders minister in word; deacons in deed.

## Male (Only) Elders

Besides the consistent pattern of male leadership in the Bible, there are two reasons in 1 Timothy 3 itself to indicate the elders were men and not women.

First, an overseer, we are told, must be "the husband of one wife" (3:2). Literally, he must be "a one-woman man." Paul isn't requiring marriage as a prerequisite for eldership (he wasn't married, and neither was Jesus) as much as he is requiring faithfulness. Paul assumes that an elder will be a faithful man.

Second, the fact that the qualifications for overseers follow immediately on the heels of Paul's injunctions concerning women in the church suggests that when he prohibited women from teaching

and exercising authority over men, he may have had eldership in mind. A closer look at eldership in 1 Timothy reveals that the two unique functions given to elders are teaching (3:2) and ruling (5:17)—the two activities specifically denied to women in the church. Paul's command in 2:11–12 essentially and functionally prohibits women from serving as elders.

## Female Servants

First Timothy 3:11 is the center of no small amount of controversy. The Greek word *gynaikas* can mean "women" or "wives" depending on the context. If the word means "their wives," then Paul is commanding the deacons' wives to be noble women. If, however, the word is better understood as "women," then it looks as if Paul is giving the qualifications for deaconesses, or at least a subset of the office of deacon that could be filled by women. While both interpretations are perfectly valid from the grammar itself, I've come to believe that "their wives" is the better translation and that Paul does not envision an office of deaconess, though, depending on your church's polity, using that term need not be inappropriate.

In support of the translation "their wives" and the interpretation that follows, it can be argued: (1) It would be strange for Paul to introduce another office in the middle of his instructions for deacons. If verse 11 is not about "their wives," Paul confusingly changes topics twice in two verses. Verse 12 is clearly about deacons, so it makes more sense that verse 11 is another requirement for deacons. (2) The requirement to "be the husband of one wife" in verse 12 makes sense on the heels of qualifications for the wives in verse 11. (3) If Paul were giving requirements for deaconesses,

you would think that he would include something about their families, about being a one-man woman. (4) The deacons must be tested first (3:10), while this is not required of the women in verse 11. (5) The reason the character of elders' wives is not mentioned is that, though they can partner with their husbands in important ways, the wives of elders would not assist in their teaching-ruling ministry in the same way that the wives of deacons would help in their service work. This explains why Paul gives instructions to deacon wives, but not to elder wives.[1]

Since the Reformation, most Protestant exegetes have understood verse 11 to be a reference to the wives of deacons, but even if "women" were serving in a more formal role, the practical application would be similar. Whether the verse is talking about wives who help their husbands in their diaconal work, or about women doing diaconal work as deaconesses, the outcome is that women are doing the same kind of work. There is nothing in the nature of diaconal-service ministry to preclude, by necessity, a woman serving as a deaconess. Phoebe was a *diakonos*, after all (Rom. 16:1). Granted, today many churches accord ruling authority to deacons, so the best way to utilize the serving gifts of women, and title (if any) to use for this role, will depend on the church's broader theology of governance. Because of my Presbyterian understanding of ordination and the authority inherent in church office, I am not in favor of women deacons in my denomination. But insofar as diaconal ministry is service oriented, diaconal work is completely open to women.

## Life Together in the Church

Even though the next section in the book is called "Questions and Applications," it would be good at the end of these exegetical

chapters to sum up with some on-the-ground practicalities for life together in the church.

In general, I see two bad approaches to applying complementarian principles. The first approach is too restrictive, defaulting to "traditional" women's roles that may or may not be rooted in Scripture. The second approach is too loose, insisting that a woman can do whatever an unordained man can do. Both approaches lack the nuance necessary to apply all the realities we've seen—from the design in Genesis, to Jesus's inclusion of women, to Paul's twofold prohibition against women teaching men and having authority over men.

Before I touch on some of the activities reserved for men, let me stress many of the things women can do.[2] Women can minister to the sick, the dying, the mentally impaired, and the physically handicapped. They can share their faith, share their resources, and open their home to strangers. They can write, counsel, mentor, organize, administrate, design, plan, and come alongside others.

They can pray.

They can serve on committees of the church. They can come alongside the elders and deacons in difficult situations involving women or those needing a woman's perspective. They can minister to single moms, new moms, breast cancer survivors, and abuse victims. They can bring meals, sew curtains, send care packages, and throw baby showers. They can do sports ministries, lead women's Bible studies, teach systematic theology to other women, and plan mission trips. They can teach children. They can raise their kids to the glory of God, and they can embrace singleness as a gift from God.

I pray for women who love to cook and quilt and work in the nursery. I pray for women (not the male elders, but women) to counsel almost-divorced wives and mentor young ladies and teach the Bible and good doctrine to other women (oh, how we need women who love the Bible and good doctrine!).

Women can help widows; they can care for those struggling with the remorse of abortion; and they can show the glory of the gospel in racial and ethnic reconciliation. And they can do all of the above cross-culturally in unreached places and with the unwanted peoples of the world. In other words, there are ten thousand things women can be doing in ministry. Pastors especially need to make this point abundantly and repetitively clear.

I trust the reader can tell that this is not mere throat clearing to get on to my *real* point about all the things women can't do in the church (in fact, there are many things woman can do—from incubating human life to caring for other women—that men can't do). In both of the congregations I've had the privilege of serving as senior pastor, I've ministered alongside godly, capable, strong, humble, smart, kind, gifted, complementarian women. I've learned from them and benefited from their ministry on staff, in prayer, on committees, and in dozens of informal—but no less important—ways.

What about the boundaries then?

For starters, the offices of the church are reserved for capable, qualified men. The very nature of the office of elder/pastor/over-seer is one of teaching and authority, which precludes women from holding this office. With my understanding of polity, the office of deacon is reserved for men as well, but I understand some

churches do not accord any authority to deacon, nor do they have the high view of office that Presbyterians do.

Women should not preach in our worship services nor teach men. The principle of 1 Timothy 2:12 is clear enough, but the application takes a lot of wisdom and wrestling, and even complementarians may apply the principle differently. It would be nice if there were no gray areas of biblical obedience, but there are. We must find ways to argue for our application of complementarian principles without being argumentative.

Women can teach a children's Sunday school class. That seems clear to me; they teach their own kids, after all. What women should be doing with teenage children and older gets less clear. The question is, when does a boy become a man, or when is he no longer under his parents' authority but on his own? In our culture the transition time for this seems to be after high school, usually in college. Again, I realize there is ambiguity here, and some of you may feel that this is just splitting hairs, but this is the sort of thinking we have to do when applying biblical principles to real life. It seems to me that the older a boy gets, the more important it is for him to be instructed by men. He will be more receptive and more likely to grow into mature manhood this way. I wouldn't have a problem with women teaching high schoolers, but even then, I would not think it wise if a woman was the main teacher on a weekly basis. I would believe this more strongly for students in college.

Sunday school and small groups are two areas where complementarians often disagree on how to apply their principles. My basic rubric is to think about Paul's two categories in 1 Timothy 2:12—teaching men and exercising authority over men. While

these categories easily map on to the eldership, it's striking that Paul's argument is first of all about function and activity, not office and ordination. Paul's prohibitions lead me to think that the regular teaching in mixed Sunday-school classes and the regular leading of a mixed small group should be done by men. Of course, there are all sorts of possible variables at play—the topic, the way the content is delivered, who else might be leading or teaching— but as a general rule we have men teach the mixed adult classes at our church and men (or couples) lead mixed adult small groups.

I believe godly women can pray or share in a church service, provided they are not taking up responsibilities that most people in that context would associate with pastoral duties.

I believe godly women can serve on task forces and committees, provided those bodies do not exercise de facto (or explicit) authority over men in the church or in the broader network or denomination.

Finally, I believe that in all of this the most important message is not what women cannot do but what men *must* do. Almost every pastor will tell you that the women in his church are more spiritually minded, more interested in reading their Bibles, more eager to grow in their faith, and more open to serving in the church. No doubt, many times where women have ventured into areas of teaching and authority reserved for men, they did so not out of a rebellious heart but because men had already relinquished their God-given mandate to spiritually lead, protect, and provide. It is all too common for the reversal of the garden to play out in our churches. Yes, women bear responsibility in that reversal, but, as we saw with Adam, God holds men ultimately responsible.

*[handwritten margin note: It's for Both Reasons]*

I'm convinced that in most cases if men behave and lead as godly, humble, self-sacrificing biblical *men*, then women will happily live and flourish in the responsibilities God has designed for them. The biblical burden of this chapter, this first section, and really this whole book, rests primarily with men. Complementarianism is often caught before it is taught, and men are the ones who do the most to make complementarianism look like catching the flu or winning the lottery. So, guys, let's not make the heartbeat of our message, "Women, sit down," when it should be, "Men, stand up."

# QUESTIONS AND APPLICATIONS

8

# Common Objections

NOT SURPRISINGLY, given the controversial nature of sex and gender in our world, almost every conclusion argued for in the first half of the book is disputed by someone somewhere. On the one hand, we want to be humble before the Lord and before each other, acknowledging that we can make interpretive mistakes. On the other hand, we don't want to undermine practical biblical authority by declaring that all we have are "interpretations." The existence of rival interpretations does not preclude that one of them is right or at least more correct than another. "Come now, let us reason together," is necessary advice for God's people today as much as it ever has been (Isa. 1:18).

With that in mind, let me address a number of common objections to the understanding of manhood and womanhood I've been arguing for and calling us to celebrate.

## Objection 1: Galatians 3:28

> There is neither Jew nor Greek, there is neither slave nor free, there is no male and female, for you are all one in Christ Jesus. (Gal. 3:28)

For some Christians, this text settles the question of gender roles in the church. While Paul's teachings in 1 Corinthians and 1 Timothy were more occasional, they argue, this is clearly transcultural. Galatians 3:28 is *the* verse. Nothing can be understood about men and women apart from it, and every verse must go through it in order to have validity.

But aside from the questionable approach of making this verse the final word on the subject, does this verse actually teach what some Christians claim? Does Galatians 3:28 obliterate gender-specific roles in the church?

Consider the broader context of Galatians. Paul is trying to forge a theological path through the Jew-Gentile controversy ravaging the church. The main issue at stake is whether Gentiles have to start living like Jews in order to be saved. This in turn brings Paul back to the larger question of what it means to be a true "Jew" in the first place. Do we receive the Spirit by the law or by believing (3:2)? Are we justified by the law or through faith (2:16)? Paul's clear answer is that we are declared right before God through faith in Christ.

But some Jews were in danger of missing the boat. Peter, for example, had to be rebuked because he refused table fellowship with Gentiles (Gal. 2:11–14). Apparently, some in Galatia were making the similar error of thinking the Jews and Gentiles were on a different spiritual plane. Against this error, Paul strenuously argues that we are all one in Christ.

So what does it mean that we are all one? In what way is there neither male nor female? Does sexual difference cease to matter for those in Christ? Certainly not, or the logic behind Paul's condemnation of same-sex sexual intimacy would not make sense (Rom. 1:18–32). Nowhere in Paul's letters do we get the smallest hint that male and female have ceased to be important categories for life and ministry. Paul is not obliterating sexual difference across the board. Rather, he is reminding the Galatians that when it comes to being right before God and being together in Christ, the markers of sex, ethnicity, and station are of no advantage.

At the risk of importing our modern sensibilities into the biblical world, we can say, in a carefully defined sense, that Paul teaches an equality between the sexes. Both men and women are held prisoners under the law (3:23), both are justified by faith (3:24), both are set free from the bonds of the law (3:25), both are sons of God in Christ (3:26), both are clothed in Christ (3:27), and both belong to Christ as heirs according to the promise (3:29). Paul's point is not that sexual maleness and femaleness are abolished in Christ, but that sexual difference neither gets one closer to God nor makes one farther from him.

### Objection 2: Ephesians 5:21

. . . submitting to one another out of reverence for Christ. (Eph. 5:21)

Hopefully, no one will deny that we are to love one another, prefer others above ourselves, deal gently with each other, respond kindly, and treat others with respect and humility. That's a kind of "mutual submission" I suppose, but is that what the text is

talking about? Some Christians maintain that mutual submission cancels out differences in marital responsibilities and structures of authority. Even if wives are told to submit to their husbands (and the Greek word is implied but not stated in verse 22), this is only in the context of already submitting to one another. That's the argument, but does it hold up?

The key to understanding verse 21 is to look at what comes next. Following the injunction to submit to one another, Paul outlines the proper relationship between different parties. Wives should submit to husbands, children obey their parents, and slaves obey their masters. Paul has in mind specific relationships when he commands mutual submission. His concern is not that everyone deal graciously and respectfully with one another (though that's a good idea too) but that Christians submit to those who are in authority over them: wives to husbands, children to parents, slaves to masters. Submitting to one another out of reverence for Christ means that we submit to those whose position entails authority over us.[1]

Any other meaning of Ephesians 5:21 does not do justice to the Greek. The word for submission (*hypotasso*) is never used in the New Testament as a generic love and respect for others. The word *hypotasso* occurs thirty-seven times in the New Testament outside of Ephesians 5:21, always with reference to a relationship where one party has authority over another. Thus, Jesus submits (*hypotasso*) to his parents (Luke 2:51), demons to the disciples (Luke 10:17, 20), the flesh to the law (Rom. 8:7), creation to futility (Rom. 8:20), the Jews to God's righteousness (Rom. 10:3), citizens to their rulers and governing officials (Rom. 13:1, 5; Titus 3:1; 1 Pet. 2:13), spirit of the prophets to the prophets (1 Cor.

14:32), women in the churches (1 Cor. 14:34), Christians to
God (Heb. 12:9; James 4:7), all things to Christ or God (1 Cor.
15:27, 28; Eph. 1:22; Phil. 3:21; Heb. 2:5, 8; 1 Pet. 3:22), the
Son to God (1 Cor. 15:28), wives to husbands (Eph. 5:24; Col.
3:18; 1 Pet. 3:1, 5), slaves to masters (Titus 2:9; 1 Pet. 2:18);
the younger to their elders (1 Pet. 5:5), and Christians to gospel
workers (1 Cor. 16:16). Nowhere in the New Testament does
*hypotasso* refer to the reciprocal virtues of patience, kindness, and
humility. It is always for one party or person or thing lining up
under the authority of another.

## Objection 3: Slavery

Christians are often embarrassed by the Bible's seeming indif-
ference toward, or even endorsement of, slavery. Since the New
Testament household codes command the wife's submission *and*
the slave's obedience, some Christians conclude that both injunc-
tions must be cultural. They argue that God did not create slavery
or male headship; he simply regulated them. And even though the
New Testament does not overturn these patterns, it does encour-
age equality and respect among all people, sowing the seeds for
the full emancipation of women and slaves in the future.

What are we to make of this argument? The best way to ap-
proach this objection is to start with an honest assessment of the
Bible's take on slavery. It's true that the Bible does not condemn
slavery outright. Remember, however, that slavery in the ancient
world was not about race. In America, you can't talk about slav-
ery without talking about blacks and whites. But that wasn't the
context in the ancient world. Slavery was a lot of things, but it
wasn't a race thing.

But still, why didn't Paul, or Jesus for that matter, denounce the institution of slavery? For starters, their goal was not political and social revolution. To be sure, political and social change followed in their wake, but their primary goal was spiritual. They proclaimed a message of faith and repentance and reconciliation with God. They simply did not comment on every political and social issue of the day. In fact, Paul in the book of Acts is eager to demonstrate that being a Christian did not make one a rabble-rouser or insurrectionist.

More to the point, the New Testament does not condemn slavery outright because slavery in the ancient world was not always undesirable (considering the alternatives). Some persons sold themselves into slavery to escape grinding poverty. Others entered into slavery with hopes of paying off debts or coming out on the other side as Roman citizens. Slavery didn't have to be a permanent condition. It could be a process toward a better lot in life.

Of course, we don't want to paint a rosy picture of slavery in the ancient world. It was dehumanizing and unbearable. Masters could treat their slaves cruelly and force them—male and female, young and old—into sexual degradation. Nevertheless, slavery could be a manageable way out of dire poverty. In the Old Testament, for example, there were a number of ways for slaves to gain their freedoms. In some circumstances, you were set free after six years. Other times, a relative could purchase your freedom or you could purchase it yourself. And at the Year of Jubilee, Hebrew slaves were released and received back their inheritance. The Old Testament regulated slavery in a number of ways without ever explicitly condemning it.

And yet, while the Bible does not condemn slavery outright, it never condones it, and it certainly never commends it. Slavery is not celebrated as a God-given gift like children are. Slavery was not pronounced good before the fall like work was. Chrysostom, preaching in the fourth century, explained the marriage passage in Ephesians 5 and the slavery passage in Ephesians 6 in very different terms. On why wives should submit to their husbands, he writes:

> Because when they are in harmony, the children are well brought up, and the domestics are in good order, and neighbors, and friends, and relations enjoy the fragrance. . . . And just as when the generals of an army are at peace with one another, all things are in due subordination . . . so, I say, it is here. Wherefore, saith he, "Wives, be in subjection unto your husbands, as unto the Lord."[2]

Chrysostom assumes submission in marriage to be an unqualified good. But when it comes to slavery in Ephesians 6, he comments:

> But should anyone ask, whence is slavery, and why it has found entrance into human life . . . I will tell you. Slavery is the fruit of covetousness, of degradation, of savagery; since Noah, we know, had no servant, nor had Abel, nor Seth, no, nor they who came after them. The thing was the fruit of sin, of rebellion against parents.[3]

Clearly, Chrysostom's approach to slavery is much different than to submission. Headship and submission in marriage were self-evident to him, even when the justification for the institution of slavery was not.

Slavery is never rooted in God's good purposes for his creation. In fact, slavery as it developed in the New World would have been outlawed in the Old Testament. "Whoever steals a man and sells him, and anyone found in possession of him, shall be put to death" (Ex. 21:16). That command alone would not allow for anything like the African slave trade. Likewise 1 Timothy 1:8–10:

> Now we know that the law is good, if one uses it lawfully, understanding this, that the law is not laid down for the just but for the lawless and disobedient, for the ungodly and sinners, for the unholy and profane, for those who strike their fathers and mothers, for murderers, the sexually immoral, men who practice homosexuality, *enslavers*, liars, perjurers, and whatever else is contrary to sound doctrine.

The Bible clearly condemns taking someone captive and selling him into slavery.

While Paul did not encourage widespread political revolution and the overthrow of the institution of slavery, he did encourage slaves to gain their freedom if possible. "Each one should remain in the condition in which he was called. Were you a bondservant when called? Do not be concerned about it. (But if you can gain your freedom, avail yourself of the opportunity)" (1 Cor. 7:20–21). When Paul sent the runaway slave turned Christian, Onesimus, back to his Christian master, Philemon, Paul gave Philemon this advice:

> For this perhaps is why he was parted from you for a while, that you might have him back forever, no longer as a bondservant but more than a bondservant, as a beloved brother—especially

to me, but how much more to you, both in the flesh and in the Lord. (Philem. 15–16)

Far from commending slavery as an inherent good, Paul encouraged slaves to gain their freedom if possible. Additionally, he exhorted masters like Philemon to welcome their slaves, not as slaves, but as brothers.

The bottom line is that the Bible, without commending it to us, regulated the institution of slavery where it existed. I imagine if Paul were writing to families today with stepchildren and stepparents, he might say something like, "Children, obey your stepdads, for this is right in the Lord. Stepdads, love your stepchildren as if they were your very own. For God loves you though you once did not belong to him." If that's what Paul wrote to us, we would know how children and stepdads should relate to each other, but we wouldn't have any warrant for thinking that Paul was in favor of divorce and remarriage. We would realize he is not commenting one way or the other on the situation. He is simply regulating an arrangement that already exists and has no signs of going away, even if the existence of the arrangement was not a part of God's good design from the beginning.

### Objection 4: Women in Ministry in the Bible

"What about all the women engaged in ministry in the Bible?" some may ask. Women in ministry is not the problem (it is to be encouraged!). The problem is women in *inappropriate* positions of ministry. Some Christians, of course, argue that there are no inappropriate roles for women. To bolster their claim, they point to what they see as a myriad of women throughout the Bible in

positions of leadership. For example, one might argue that the commands in 1 Timothy 2 must be uniquely for the situation in Ephesus, because a number of women throughout the Bible taught and exercised authority over men.

Let's look briefly at several of the most common examples and see if these women exercised the kind of authority and engaged in the kind of teaching out of step with the pattern in Genesis and the activities prohibited by Paul.

## Deborah

Deborah seems to be a glaring exception to the rule laid out in 1 Timothy 2. She was a prophetess, and a judge, and she oversaw a period of victory and peace in Israel (Judg. 4–5). While Deborah fulfilled these important roles, she performed them uniquely as a woman and in different ways than the men who had served in these capacities. First, she seems to be the only judge with no military function. Deborah, instead, is instructed to send for Barak (a man) to conduct the military maneuvers (4:5–7). Even when Deborah goes with Barak into battle, he is the one who leads the ten thousand men into the fray (4:10, 14–16). Second, Barak is rebuked for insisting that Deborah go with him in the first place. Deborah willingly handed over the leadership to Barak and then shamed him for his hesitation (4:9). Hence, the glory would not go to Barak but to Jael, the wife of Heber the Kenite (4:9, 22). Third, whatever sort of authority Deborah shared with Barak, it was not a priestly or teaching authority.

## Prophetesses

Besides Deborah, several other women are called prophetesses in the Old and New Testaments: Miriam (Ex. 15:20), Huldah

(2 Kings 22:14), Noadiah (Neh. 6:14), Anna (Luke 2:36), and Philip's daughters (Acts 21:8–9). Two comments may help put the ministry of prophetesses in its proper context. First, recall that New Testament prophecy was not identical with other forms of word ministry. Congregational prophets in the New Testament were given occasional Spirit-prompted utterances that needed to be weighed against accepted teaching. Philip's daughters and the prophets at Corinth were not the same as preachers or authoritative teachers.

Second, in the Old Testament, where prophecy carries absolute authority, we see women prophetesses carrying out their ministry differently from male prophets. Miriam ministered to women (Ex. 15:20), and Deborah and Huldah prophesied more privately than publicly. In contrast to prophets such as Isaiah or Jeremiah who publicly declared the word of the Lord for all to hear, Deborah judged among those who came to her in private (Judg. 4:5) and instructed Barak individually, while Huldah prophesied privately to the messengers Josiah sent to her (2 Kings 22:14–20). Noadiah, the only other prophetess mentioned in the Old Testament, opposed Nehemiah along with the wicked prophet Shemaiah. The example of Noadiah, disobedient as she was, tells us nothing about God's design for women in ministry.

## Priscilla

Mentioned three times in the book of Acts and three times in the Epistles, Priscilla/Prisca was obviously well known in the early church (Acts 18:2, 18, 26; Rom. 16:3; 1 Cor. 16:19; 2 Tim. 4:19). She is most often listed first before her husband, Aquilla, which may or may not be significant. Perhaps she was the more

prominent of the two, or maybe she converted before her husband, or maybe the disciples just got to know her first (like when you are friends with Sally for a long time and then she marries Joe so you refer to them as "Sally and Joe"). In any case, together they instructed the influential teacher Apollos. But again, this teaching was done in private (Acts 18:26). Priscilla may have been learned, wise, and influential, but there is no indication that she exercised teaching authority over men.

### Phoebe

Paul commends Phoebe to the Romans as a *diakonos* of the church in Cenchrea (Rom. 16:1). This may mean that Phoebe was a deaconess or that she was more generally a servant. The word itself is ambiguous. In either case, there is no indication that Phoebe the servant was a teacher or leader over men.

### Junia

Paul gives Andronicus and Junia greetings, hailing them as "outstanding among the apostles" (Rom. 16:7 NIV). Some Christians use this verse to argue that a woman can exercise authority over men because Junia (a woman) was an apostle. This is a thin argument for several reasons. First, it is likely that Junia (*iounian* in Greek) is a man, not a woman.[4] Second, "outstanding among the apostles" suggests that Junia was held in esteem by the apostles, not that she was an apostle. Third, even if Junia was a woman and was an apostle, it is not clear that she was an apostle like the twelve. *Apostle* can be used in a less technical sense as a messenger or representative (2 Cor. 8:23; Phil. 2:25).

## Euodia and Syntyche

Euodia and Syntyche (both women) were fellow workers with Paul, who contended at his side in the cause of the gospel (Phil. 4:3). Nothing here implies teaching or authority over men. There are hundreds of ways to work for the cause of this gospel without violating the norms established in 1 Timothy and the patterns found in the rest of Scripture. Without apology, we ought to fully affirm the important work Euodia and Syntyche performed, and millions of women continue to do, in the cause of the gospel, without thinking that their presence in ministry somehow overturns the biblical teaching on men and women in the church.

## Elect Lady

Some maintain that the "elect lady" in 2 John is the pastor/elder of the church. The elect lady, however, is not the pastor of the church; she is the church. Not only is the letter much too general to be addressed to a specific person (cf. 3 John), and not only is female imagery often used of the church (cf. Eph. 5; Rev. 12), but, most decisively, John uses the second-person plural throughout 2 John, indicating that he has not an individual in mind but a body of believers (vv. 6, 8, 10, 12).

## Objection 5: Gifts and Calling

Women have vital spiritual gifts. No one is denying that. Women can even have gifts of teaching and leadership. We all know women who are great organizers, administrators, communicators, and leaders. No one wants to waste those gifts. But the Bible

stipulates certain ways in which these gifts are to be used[Women can, and should, exercise powerful gifts of teaching, provided it is not over men. Surely teaching children and other women is not a waste of a woman's gifts?]

Moreover, the fact that people have benefited from women's gifts wrongly used (having teaching authority over men) is an argument based on effect more than obedience. That God uses us at all, when we as a church seem to stray from his word so frequently, is a testimony to God's grace, not a blueprint for ministry. God has blessed the public teaching of women over men despite themselves, just as God has used me to bless others despite myself. The goal in both cases, hopefully, is to know the truth more clearly and approximate it more nearly. "But it works" is the wrong measure of our faithfulness.

Likewise, we cannot make decisions about church leadership by a general appeal to the priesthood of all believers. I've heard it said, "Yes, yes, the priests in the Old Testament were all male, but that has no bearing on New Testament leadership models, because now we are all 'a royal priesthood' and 'holy nation'" (see 1 Pet. 2:9). It is true that we—women as well as men—are a royal priesthood. But Peter's New Testament description of the church was simply a reiteration of God's word given to the people at Sinai when he declared, "You shall be to me a kingdom of priests and a holy na-tion" (Ex. 19:6). The priesthood of all believers is an Old Testament idea (and it is about our corporate holiness, not our corporate gifting anyway). If an all-male priesthood was consistent with an every-person kingdom of priests in the Old Testament, there is no reason to think that an all-male eldership is inconsistent with the priesthood of believers in the New Testament.

Similarly, the appeal to calling is not very convincing. Years ago, the Roman Catholic periodical *First Things* ran two essays on the ordination (for and against) of women. The woman writing in favor of women's ordination concluded her piece by appealing to a sense of calling:

> Much has been said here of why there is no reason *not* to ordain women. A word or two as to why it *should* be done is yet needed. . . . As Sister Thekla once said, "The only justification for the monastic life lies simply in the fact that God calls some people to it." By the same token, the only justification for the ordination of women lies in the fact that God calls some women to it.[5]

Though a call may be honestly felt, making such an appeal the decisive factor is dangerously subjective. I have no problem with people referring to their vocation, pastoral or otherwise, as a "calling," if by the term they simply mean to acknowledge a spiritual purpose in their work. But as a decision-making tool, trying to discern one's "calling" by internal feelings and impressions is an unsure guide. God's objective revelation in Scripture must have priority over our subjective understanding of God's will for our lives.

9

# Growing Up as Boys and Girls

AS I WRITE THIS BOOK, I'm in the middle of raising my kids. My saintly wife and I have nine children. Their ages range from almost-leaving-for-college to just-entered-the-world. Our basic parenting philosophy is feed them, clothe them, love them, laugh with them, correct them, bring them to church, and try to stay alive. With five boys and four girls, considering the ways in which men and women differ is not merely a matter of intellectual curiosity. It's immediately relevant.[1]

In my own thinking and writing on the topic of men and women, I've found John Piper's question extremely helpful: *If your son asks you what it means to be a man, or your daughter asks you what it means to be a woman, what would you say?* I appreciate the real-world practicality of the question. I have sons and daughters, and they need to know (and as they get older, they want to know) what it means to be a man or a woman.

I could talk about being made in God's image and growing in Christlikeness. Indeed, I should talk about these things often. But

the question about growing up into a man or a woman sharpens the tip of the theological spear. "Daddy, what does godliness look like for me *as a boy*?" "What does godliness look like for me as *a girl*?" Godliness for my sons and my daughters will look the same in all sorts of foundational ways, but it will also look different in a host of other ways.

Sexual complementarity means not only affirming the existence of "a host of other ways" as a general truth, but also trying to help men and women practically know what these differences entail. If complementarity means anything, then surely it is about, at least in part, the inherent goodness in the divinely designed *difference* between the sexes. If we don't say anything about that difference—and how it's wonderfully true and beautiful and promotes the flourishing of men and women and children and families and churches and society—then we are neglecting the uniquely good news of this thing we call complementarianism.

So what might I tell my children about being a man or a woman? I'd try to make it simple as their ABCs:

Appearance
Body
Character
Demeanor
Eager Posture

At the risk of being confusing, let's consider each topic as it's revealed in Scripture, not in alphabetical order. You may notice some overlap with the exegetical sections earlier in the book, but hopefully by pulling together a number of themes in this chapter,

we will get a better idea of what sexual difference and complementarity look like on the ground and in living color.

## Eager Posture

> Then the LORD God said, "It is not good that the man should be alone; I will make him a helper fit for him." (Gen. 2:18)

In the first chapters of Genesis, Adam is created to lead. He was created first, he was charged with naming the animals (2:19–20), he was given the probationary command (2:16–17), and even though Eve ate the forbidden fruit first, God holds Adam responsible (Rom. 5:12–21; cf. Gen. 3:9). Eve was created to be his helper (cf. 1 Cor. 11:3). In Scripture, a helper is not a demeaning role and does not imply inferiority. In fact, Yahweh is often called a "helper" of his people in the Old Testament. At the same time, Genesis 2 affirms that by God's design, according to the order of creation, the woman is to help her husband. That is her eager posture.

I use the word *posture* deliberately. Posture is a flexible thing. You can slouch, you can sit upright, be casual or formal, lean in or lean back. I use the word *posture* because we're not talking about an inflexible office but about an inclination. The wife should be willing to be led and the husband eager to take the sacrificial initiative to lead. It would be wrong—sinful even—for a husband to tell his wife, "You're the helper; I don't help you." The fact that men were created to lead does not mean that men lead to the exclusion of helping or that women help and are never able to exercise leadership.

Instead, I'm simply noting that male leading and female helping is what men and women should be intentional to find and eager to

accept. Even in the workplace, where a company's org chart may have men and women positioned at every level, I believe there is still a way for Christians to embrace masculinity and femininity in appropriate ways. This inclination is seen most clearly—in the Bible and in practice—in marriage, but there are reasons to think the Genesis pattern reflects realities that go beyond the marriage relationship. We see for Paul that the Genesis pattern was to be reflected in how women learn and how men teach in the church (1 Tim. 2:11–14). Or consider once again the example of Deborah. She was undoubtedly a strong woman whose influence was important, but she (implicitly) rebuked Barak for not leading the army into battle (Judg. 4:6–9). He and his men were to take the lead in Israel (Judg. 5:2, 9).

This point about posture often has more to do with what men ought to be doing than what women should not be doing. The exhortation here is not for women to sit down but for men to stand up. A man who leads in love makes it much easier for a woman to humbly help.

## Body

> You shall not lie with a male as with a woman; it is an abomination. (Lev. 18:22)

The world claims that orientation is more essential than biological sex. It further claims that gender is a construct. Our actions, therefore, should correspond to our self-authenticating desires more than to our biological realities.

The Bible tells a different story. Biological sex, far from being incidental or malleable, carries with it its own sense of ought-ness.

Our actions, therefore, must correspond to our divinely designed sexual identity. The male body, for example, is not designed to fit together in a one-flesh union with another man. This is why Paul uses the language of "fittedness" or "natural relations" in Romans 1:26–27:

> For this reason God gave them up to dishonorable passions. For their women exchanged natural relations for those that are contrary to nature; and the men likewise gave up natural relations with women and were consumed with passion for one another, men committing shameless acts with men and receiving in themselves the due penalty for their error.

Throughout Romans 1, Paul employs the language of Genesis 1 to describe human idolatry and rebellion. In the text above, Paul recalls how God created both male and female in Genesis 1 as a complementary pair—a natural and functional biological unity that two women or two men cannot re-create.

Natural revelation suggests that our physiology corresponds to a divine moral injunction. When two men are together sexually, the member that is supposed to give life is often placed in a part of the body where death and decay are expelled. I don't mean to be graphic, but the purposeful fittedness of the male and female sexual organs is too important to ignore. Even apart from supernatural revelation, we can see that our bodies were designed to fulfill the creation mandate. Using our sexual organs for any alternative purpose is unnatural and a rebellion against the order established by our Creator.

Why is it that the sexual act is so powerful? Why is it that God determined sex as the moment of one-flesh union? Why

not holding hands or locking arms? Because God endowed the unique male/female sexual union with the procreative ability—the ability to fulfill the creation mandate in Genesis 1, to replenish the earth, to multiply, to fill the earth and subdue it.

One of the most countercultural verses in all of Scripture is 1 Corinthians 6:19–20: "Do you not know that your body is a temple of the Holy Spirit within you, whom you have from God? You are not your own, for you were bought with a price. So glorify God in your body." As we teach our children at home and in the church, we must not merely skip to the right conclusions without unfolding for them all of the arguments that lead to those conclusions. Don't merely teach "sex is between a man and a woman in the covenant of marriage." Explain why that is the case.

The body is not incidental to our purpose as human beings. God created our bodies and called them good. This same God took on human flesh in the incarnation. God is going to resurrect our bodies. Our bodies are therefore not incidental, and how we use our bodies is not a separate matter from who we are and how God made us to be. God created male bodies and female bodies, different bodies that carry moral "oughts" according to God's good design.

### Appearance

> For if a wife will not cover her head, then she should cut her hair short. But since it is disgraceful for a wife to cut off her hair or shave her head, let her cover her head. (1 Cor. 11:6)

> Judge for yourselves: is it proper for a wife to pray to God with her head uncovered? Does not nature itself teach you that if

a man wears long hair it is a disgrace for him, but if a woman has long hair, it is her glory? For her hair is given to her for a covering. (1 Cor. 11:13–15)

Paul's argument in 1 Corinthians 11 is complicated, but at its core he is asserting that confusing the appearance of our genders is contrary to nature. When Paul says that nature itself teaches long hair is a disgrace to man, he's not making a universal statement about hair length. He is asserting a universal statement that confusion of the sexes is contrary to nature. As we noted earlier, men should not seem to be women or express themselves in a feminine way, nor should women express themselves in a masculine way or seem to be men.

I'll admit, this principle is tricky. We must be careful not to equate biblical manhood and womanhood with one-dimensional cultural stereotypes—real men drive pickup trucks, hunt, fish, and watch football; real women bake cookies, sew, share their feelings, and watch the Hallmark Channel. Stereotypes can be harmful when they function as unreflective and constraining prejudices.

At the same time, stereotypes usually come from somewhere. The word *stereotype*, originating in the world of printing, refers to a kind of impression. A stereotype is a cognitive shortcut. As such it can box people in, but it can also quickly point us to basic shapes and patterns. Most enduring stereotypes probably reflect a complex mix of culture and nature. Do all girls like playing with dolls? No, but most do, from a very young age, prior to intense socialization. Do all boys turn sticks into swords and guns? No, but most do, and more so than girls. There's a reason you don't

hear moms telling their boys, "Be careful in playing with those girls; they're too rough."[2]

So how might this apply in our day? Hopefully we might all agree with at least some examples. Does not nature itself teach you that if a man wears a cocktail dress it is a disgrace for him? Does not nature itself teach us that if a man puts on lipstick it is a disgrace for him? In our cultural context, these actions express femininity, not masculinity.

Pastors, parents, and church leaders must be extraordinarily thoughtful on this point. Can "real men" enjoy musical theater, ballet, or shopping? Of course they can. On the other hand, if you were discipling a young man who told you he wears pink pajamas, he loves to get his nails done every week, and he would make his wife confront an intruder in the home, you may need to have a conversation about whether he's appropriately expressing his masculinity.

Yes, I know, some of the examples are culturally situated. The Bible, of course, makes no explicit prohibitions against men being decked out in all pink. And yet if masculinity and femininity are going to have any conceptual content, we cannot avoid certain cultural cues. This makes pastoring and parenting difficult—how to say something practical about masculinity and femininity without being overly rigid. But it wouldn't be the first area where we need wisdom to apply broad principles into specific areas.

In a day when male movie pirates, figure skaters, and stand-up comedians wear eyeliner, we cannot ignore this question. The Bible may not give us every detail we might want on this topic, but it does, at least, affirm an essential truth no longer obvious in our day—it is disgraceful for a man to appear to be a woman and

a woman to appear to be a man. That is the theological foundation under 1 Corinthians 11.

I'll say it again: we must apply these truths with all the appropriate graces necessary in our discipling contexts. If some from your church struggle with gender identity issues or gender dysphoria, deal patiently with them and sympathize with struggles they're experiencing. Point them to 1 Corinthians 11, not as a way of shaming them, but for instruction. Teach them that God made men and women to be different and that when we confuse those differences we're confusing what God designed to bring him glory.

## Demeanor

> But we were gentle among you, like a nursing mother taking care of her own children. So, being affectionately desirous of you, we were ready to share with you not only the gospel of God but also our own selves, because you had become very dear to us. (1 Thess. 2:7–8)

> For you know how, like a father with his children, we exhorted each one of you and encouraged you and charged you to walk in a manner worthy of God, who calls you into his own kingdom and glory. (1 Thess. 2:11–12)

Notice what Paul is doing in these passages. First, he describes his own ministry among the Thessalonians like that of a nursing mother: gentle, affectionate, sacrificial. Second, he describes his ministry as fatherly: full of exhortation, encouragement, and leadership. Paul identifies these demeanors as corresponding with one gender more than the other.

Paul is not suggesting that one set of virtues is exclusively feminine or exclusively masculine. After all, he's describing himself as ministering "like a nursing mother." At the same time, Paul clearly suggests that certain demeanors fall naturally along gender lines. When Paul thinks of nurture, affection, and gentleness, he thinks of a mother. When he thinks of exhortation, discipline, and charge, he thinks of a father.

Yes, each man and each woman is unique. But no matter our personality types, fathering is generally marked by a hortatory demeanor and mothering is marked by gentleness—which is saying something, given the people that moms work with every day!

Ultimately, in Paul's mind a mom has a certain demeanor and a father has a different type of demeanor, and these demeanors correspond with the natural inclinations of their gender.

## Character

Likewise, wives, be subject to your own husbands, so that even if some do not obey the word, they may be won without a word by the conduct of their wives, when they see your respectful and pure conduct. Do not let your adorning be external—the braiding of hair and the putting on of gold jewelry, or the clothing you wear—but let your adorning be the hidden person of the heart with the imperishable beauty of a gentle and quiet spirit, which in God's sight is very precious. For this is how the holy women who hoped in God used to adorn themselves, by submitting to their own husbands, as Sarah obeyed Abraham, calling him lord. And you are her children, if you do good and do not fear anything that is frightening. Likewise, husbands, live with your wives in an understanding way, showing honor

to the woman as the weaker vessel, since they are heirs with you
of the grace of life, so that your prayers may not be hindered.
(1 Pet. 3:1–7)

Peter enjoins women to be respectful, pure, and gentle. He exhorts
men to show honor, be understanding, and exercise caring leader-
ship. From this passage, I conclude that the crowning characteris-
tic of a woman is true beauty and the crowning characteristic of
the man is true strength. The word *crown* is important. I'm not
suggesting true strength and true beauty are the only things to
say about men and women, just like a crown is not the only piece
of a monarch's regalia. But it is usually distinctive. We can look
at a crown and think, "That is fit for a king," or, "That was made
for a queen." A crown sits on top of the head as a final marker of
kingly or queenly splendor.

These two categories—feminine beauty and manly strength—
recur throughout Scripture. First Peter 3 focuses on instructing
women to pursue the right type of adornment. Paul gives similar
instructions to women in 1 Timothy 2:9–10:

Likewise also . . . women should adorn themselves in respectable
apparel, with modesty and self-control, not with braided hair
and gold or pearls or costly attire, but with what is proper for
women who profess godliness—with good works.

The message in both passages is the same: pursue beauty on the
inside more than beauty on the outside.

As for men, 1 Peter 3 tells them to display the right kind of
strength toward their wives, not frightening and domineering
but honoring and understanding. Men were made to be strong—

usually with bigger muscles and taller stature than women. That's why the Bible associates strength with manliness. "Be watchful, stand firm in the faith, act like men, be strong. Let all that you do be done in love" (1 Cor. 16:13–14). To be sure, this is a command to the whole church, so men *and* women are called here to be manly. But surely it is telling that Paul here associates strength and fortitude with masculinity. The word *andrizomai* ("act like men") was used in the ancient world as a call to courage in the face of danger.[3] It's the same perspective shared by a dying David when he told Solomon, "Be strong, and show yourself a man" (1 Kings 2:2).

What can we learn from Scripture's emphases on female beauty and masculine strength?

Though not universally true, it is broadly true that most women pay at least some measure of attention to cultivating external beauty, from time spent putting on makeup and fixing hair to how they dress. This attention to beauty signifies something about the created order. Women are wired for beauty. The Bible appeals to that natural feminine impulse and warns women not to settle for any lesser beauty than the internal beauty of Christlikeness. Women are made for this type of beauty; it is their crowning characteristic.

Similarly, men generally are physically stronger, more interested in sports, more willing to indulge war movies, and more inclined to activities that involve competition and risk. The hours in front of the TV watching world-class athletes run and jump and swing and shoot and shove and tackle may be telling us something. We were wired for strength, for confidence in the face of risk.[4] Tenderhearted, self-sacrificing, risk-taking strength is the crowning characteristic of men.

What do we say then to our sons and daughters who ask, "Daddy and Mommy, what does it mean to be a man or a woman?" Tell them they are made in the image of God and for union with Christ. And then tell your daughters that they should strive to be beautiful in the way God wants them to be beautiful. And tell your sons to strive to be strong in all the ways God wants them to be strong.

Yes, the cultural winds are blowing stiff and strong against the church on these issues. But the good news is that behind us lies a massive river of divine design in every human person. Ultimately, God's created order cannot be reengineered by sinful human ingenuity. Manhood and womanhood will reassert themselves. The question is whether it will be healthy or unhealthy. God made us as men and women to act like men and women. The more we see in nature (partly) and in God's word (mainly) what it means to be men and women, the better our marriages, our children, our churches, and our society will be.

# Following Christ as Men and Women

IF THE VISION OF sexual complementarity laid out in this book is to have any persuasive power in the years ahead, it must be marked by several characteristics. It must be tender, winsome, and warm. It must be grounded in Scripture and sensitive to people. It must be tough but never triumphalistic. It must be convictional, not merely traditional. It must be attuned to the mood of the culture and resolutely unwilling to give in to the culture's demands.

I remember years ago hearing a pastor describe his position on homosexuality as theologically conservative and socially progressive. I could tell by the way he was speaking that everything in him was leaning with the cultural wind. He was holding on to orthodoxy by a thin string. So I wasn't surprised a few years later when he announced that he had changed his mind on homosexuality and now saw nothing wrong with same-sex sexual relationships.

In the same way, we must be careful that our beliefs about men and women are deep, thoughtful, rooted, biblical, and resigned to the fact that we may be misunderstood and even mistreated. Faithfulness does not mean returning to some supposed golden era rooted in a particular cultural moment, nor does it mean making as many enemies as possible in this cultural moment, but it does mean that for the sake of the good, the true, and the beautiful, we will not shrink from facing opposition when it is impossible to avoid.

In an age of profound gender confusion, where the connection between biological sex and gender is routinely rejected, Christians are called upon to reaffirm that our shared human nature finds different expressions in manhood and in womanhood. As Herman Bavinck puts it, "The human nature given to man and woman is one and the same, but in each of them it exists in a unique way. And this distinction functions in all of life and in all kinds of activity."[1]

We are not philosophical nominalists who deny universals and believe only in particulars. We don't just have males and females; there also exists maleness and femaleness. God did not create androgynous human beings, and he does not redeem us to become androgynous Christians. God made us male and female, and he sanctifies us by the Spirit so that we might follow Christ *as* men and follow Christ *as* women.

The Reformed tradition has always been adamant that grace does not eradicate nature or elevate nature, but grace restores nature. God is in the business of returning us to what was once declared "very good." That means that while male and female are nothing when it comes to being justified in Christ, the fact that

we were created with a specific sex has everything to do with living as justified Christians. We must not misconstrue or despise our God-given sexual difference. God is, as Bavinck says, "the sovereign Designer of sex; man and woman have God to thank not only for their human nature, but also for their different sexes and natures."[2] One of the burdens of this book is to raise up a new generation of cheerful and unflappable Christians who will celebrate a vision of manhood and womanhood that is not only *biblical* but in a profound sense *natural* as well.

## The Nature of Things

I belabor this point because I fear that the "rules" of complementarianism—male headship in the home and male eldership in the church—are sometimes construed as divine strictures absent any deeper recognition of natural theology and sexual difference. Allow for a homely analogy. Suppose you have two identical basketballs—one you reserve for outdoor use and one you set aside for indoor use. The "rules" of complementarianism are not like the arbitrary labeling of two basketballs. They both work the same way and can essentially do the same thing, except that God has decreed that the two basketballs be set apart for different functions. That's a capricious complementarianism held together by an admirable submission to Scripture, but in time it will lack any coherent or compelling reason for the existence of different "rules."

But suppose you have a basketball and an American football. They are similar things, used toward similar ends. You could even attempt to use the two balls interchangeably. But the attempt would prove awkward, and in the long run the game would change if you kept shooting free throws with a football or kept trying to

execute a run-pass option with a basketball. The rules for each ball are not arbitrary. They are rooted in the different structure, shape, and purpose for each ball. It's not the nature of a basketball to be used in football. In other words, the rules are rooted in nature.

Any attempt to recover biblical manhood and womanhood, or any effort as Christians to recover from the recovering, must start with the recognition that sexual difference is not simply a marker of who may hold the office of elder; it is an indication of the sort of image bearer God wants us to be in all of life. Of course, this does not mean we are bound to impermeable definitions of masculinity and femininity. As Bavinck observes, "No man is complete without some feminine qualities, no woman is complete without some masculine qualities."[3] But the fact that we can speak of some qualities being feminine and some being masculine assumes that sexual difference is real and can be identified.

Nature itself teaches this distinction. The man and the woman, Bavinck points out, differ in physical structure and physical strength, in different rights and duties, in different work before and within marriage, and in different responsibilities relative to the home and to the world.[4] Later, Bavinck admits that describing the distinctions "crisply and clearly" between man and woman is difficult. Nevertheless, the distinctions exist and can be set in terms of main features. There are outward differences in size and shape, in strength and tone. There are different needs, different movements, and different capacities for suffering. There are differences in the life of the soul related to thinking, feeling, evaluating, and imagining. There are differences in the way they perceive religion and morality.[5] There are differences in the place men and women occupy in the church and in the home. If the

husband is called to be the head of the family, then the wife is called to be its heart.[6]

This design is reflected not only in the "very good" of Eden, but in the very bad as well. The sin in the garden was, among other things, a reversal of the family order. Eve took charge, and Adam followed her. Eve sinned not just as a person, but as a woman and a wife; Adam sinned as a man and a husband. Not surprisingly, then, Adam was punished in his manly calling as a cultivator of the earth, while Eve was punished in her womanly calling as a cultivator of the womb. God's callings and God's chastisements are not indifferent to sexual difference.[7]

Men and women are prone to different sins and defects. Marriage is, therefore, not just a complementary arrangement, but a corrective one. Man and woman are interdependent but not interchangeable. Marriage is God's good gift because it is "thus grounded in the nature of both."[8] When the man exercises authority in the home, he is not just filling a role; he is living out what it means to be a man. And when the woman supports her husband and cares for her children, she is doing the same relative to being a woman.

Moreover, the biblical patterns and prescriptions for husband and wife are not without bearing upon the way we view men and women more generally. We should think of marriage not as the only place where the design of Genesis is lived out, but as the place where God's design is lived out most clearly. As Harvey Mansfield concludes in his thoroughly secular book on manliness: "Individuals in our society should live as if, or to some extent as if, they were married, the men protective and authoritative as if they were husbands, the women nurturing and critical as if they

were wives."⁹ The shape of marriage, he argues, shapes all of life, because marriage is the institution that binds together and reveals the natural inclinations of the two sexes.[10] Or, if we want a more theological authority, we can go to Calvin, who, in commenting on 1 Corinthians 11:4–10, argues that Paul's instructions are not just for marriage, but reflect "the order that God has established in the world."[11] To be sure, men and women should not relate to every other man or woman as husband and wife. And yet there is something about the marriage relationship that shows for everyone the sort of people men and women were made to be.

## The Way of Wisdom and Grace

There is room for different conclusions when it comes to living out biblical manhood and womanhood. We must know our church, know our context, and know our family, and do our best to apply what we see in the Bible. But variation is one thing when we end up with different applications; it's another thing when we aren't starting from the same place. And that means a theology that elucidates rather than elides the central fact that God made us male and female. No doubt, there may be a cost—personally, vocationally, culturally—when we embrace sexual differentiation and complementarity, but let us never forget that the law of the Lord is perfect, the testimony of the Lord is sure, the precepts of the Lord are right, and the commandment of the Lord is pure (Ps. 19:7–8).

Manhood and womanhood cannot be reduced to authority and submission or to leadership and nurture. But these things are meaningful expressions of what it means to be a man and a woman, rooted not just in the names we give to people but in

nature itself. The expression of nature will not look identical in the church and outside the church, married and single, younger and older, but, importantly, it should look like something and should be visible.

Sexual difference is the way of God's wisdom and grace. It was there in the garden, there in the life of ancient Israel, there in the Gospels, there in the early church, will be there at the wedding supper of the Lamb, and was there in the mind of God before any of this began. To be sure, manhood and womanhood is not the message of the gospel. But it is never far from the storyline of redemptive history. The givenness of being male or female is also a gift—a gift to embrace, a natural order of fittedness and function that embodies the way the world is supposed to work and the way we ought to follow Christ in the world. Let us, then, as male and female image bearers, delight in this design and seek to promote—with our lives and with our lips—all that is good and true and beautiful in God making us men and women.

# Appendix

## Should Complementarian Churches Allow
## a Woman to Give the Sunday Sermon?

SUPPOSE YOU ARE in agreement with the biblical and theological arguments made in this book. You see the same patterns in Genesis and in Jesus. You read Paul's instructions the same way. You have come to the same conclusion about male leadership in the home and in the church. You do not support the ordination of women. You believe the elders and pastors at your church should be men. But you still wonder whether a woman might occasionally be able to preach a sermon on Sunday morning. I have friends who agree with all the affirmations in this paragraph who are nevertheless convinced that a woman preaching a sermon—under the authority of the elders—does not violate basic complementarian convictions. How one might come to this conclusion, and why I think the conclusion is deeply mistaken, is the point of this appendix.

The best argument I've seen for women preaching is by the Australian minister and apologist John Dickson in his book *Hearing Her Voice: A Biblical Invitation for Women to Preach.*[1] With affirming blurbs from J. I. Packer, Craig Blomberg, Graham Cole, and Chris Wright, one can see why this has been an influential book. Dickson's book is a model of clarity and accessibility. In a little more than one hundred pages, Dickson makes a thoughtful, straightforward case—as one who admits "to being a broad complementarian" (p. 88)—for the legitimacy of women preaching sermons in Sunday services.

Not surprisingly, Dickson focuses on 1 Timothy 2:12. While the application seems obvious to many of us—women aren't permitted to teach or to exercise authority, so they shouldn't preach sermons—Dickson argues that we've misunderstood what Paul meant by teaching. "Put simply," Dickson writes, "there are numerous public-speaking ministries mentioned in the New Testament—teaching, exhorting, evangelizing, prophesying, reading, and so on—and Paul restricts *just one of them* to qualified males: 'teaching'" (pp. 11–12). At the heart of Dickson's argument is a simple syllogism we could summarize like this: The only thing women can't do in worship is teach. For Paul, teaching was a technical and narrowly conceived enterprise that is not the same as our modern sermon. Therefore, women can speak in almost every way in a church service, including preaching the sermon.

So if preaching a sermon does not count as teaching, what did Paul mean by teaching? Dickson explains:

1 Timothy 2:12 does not refer to a general type of speaking based on Scripture. Rather, it refers to a specific activity found throughout the pages of the New Testament, namely *preserving and laying down the tradition handed down by the apostles*. This activity is different from the explanation and application of a Bible passage found in today's typical expository sermon. (p. 12)

Dickson builds the case for this preliminary conclusion in four parts.

*Part 1.* There are several different kinds of speaking mentioned in the Bible: prophesying, evangelizing, reading, exhorting, teaching, and so on. We know from texts such as 1 Corinthians 12:28, 1 Corinthians 14, Romans 12:4–8, and 1 Timothy 4:13 that Paul did not treat these speaking ministries as identical. Only one of these types of speaking—the activity of teaching—is restricted to men (p. 27).

*Part 2.* In the ancient world, and specifically for Paul, to teach (*didasko*) was a technical term for passing on a fixed oral tradition (pp. 34, 45). Teaching does not refer to expounding or explaining but to transmitting words intact (p. 33). With the close of the biblical canon, there is not the same need for teaching in this technical sense.

*Part 3.* In the New Testament, teaching never means explaining or applying a biblical passage (pp. 50, 54). A teacher was someone who carefully passed down the fixed traditions or the body of apostolic words from their original source to a new community of faith (pp. 57, 59, 61). Some contemporary sermons *may* contain elements of this transmission, but this is not the typical function

of weekly exposition (p. 64). What we think of as the sermon is more aptly called exhortation (p. 65).

*Part 4.* The apostolic deposit is now found in the pages of the New Testament. No individual is charged with preserving and transmitting the fixed oral traditions about Jesus (pp. 72, 74). Our preachers may be analogous to ancient teachers, but we do not preserve and transmit the apostolic deposit to the same degree, in the same manner, or with the same authority (pp. 73, 75). The typical sermon where a preacher comments on the teaching of the apostles, exhorts us to follow that teaching, and then applies that teaching is not itself teaching. The modern sermon is, depending on your definition, more like prophesying or exhorting, both of which are open to women (p. 75).

## Too Narrow, Too Thin

Dickson includes academic footnotes in making his case, as well as caveats and qualifications along the way. But the gist of his argument is arrestingly simple: teaching is not what we do when we preach a sermon. Only teaching is forbidden to women. Women, therefore, can preach sermons in our churches.

I find Dickson's thesis unconvincing for two basic reasons. *I believe his view of ancient teaching is too narrow, and his view of contemporary preaching is too thin.*[2] Let me unpack this conclusion by looking at teaching from a variety of angles.

## Teaching in the Early Church

The strength of Dickson's approach is that he rightly points to the different speaking words in the New Testament. True, teaching and exhorting and prophesying and reading are not identical. And

yet his overly technical definition of "teaching" does not fit the evidence, or in some instances even square with basic common sense. If "I do not permit a woman to teach" can mean "I permit a woman to preach because preaching doesn't involve teaching," we must be employing very restrictive definitions of preaching and teaching.

More to the point, we have to wonder why this highly nuanced reading has been lost on almost every commentator for two millennia. In a revealing endnote on the last page of the book, Dickson acknowledges:

> I have no doubt that within time the word "teaching" in the early church came to mean explaining and applying the written words of the New Testament (and entire Bible). That would be an interesting line of research, but I am not sure it would overturn the evidence that in 1 Tim. 2:12 Paul had a different meaning of this important term. (p. 104)

That is a telling admission. But it invites the question, "If 'teaching' in the ancient world clearly had a narrow meaning of repeating oral traditions, why does no one seem to pick up on this exclusively technical definition?" To be sure, the Bible is our final authority, but when an argument relies so heavily on first-century context, you would expect the earliest centuries of the church to reinforce the argument, not undermine it.

Take the *Didache*, for example.[3] This late-first-century document has a lot to say about teachers. They are supposed to "teach all these things that have just been mentioned" [in the first ten chapters of the book] (11:1). They are to teach what accords with the church order laid out in the *Didache* (11:2). Importantly, the

*Didache* assumes the existence of traveling teachers, apostles, and prophets, all of whom are said to teach (*didaskon*) (11:10–11). It is telling that "teaching" is a broad enough term to include what prophets and other speakers do, not to mention the *Didache* itself.

While "teach" can certainly include passing on oral traditions about Jesus, it cannot be restricted to only this. As Hughes Oliphant Old explains, "The *Didache* assumes a rather large body of prophets, teachers, bishops, and deacons who devote full time to their preaching and teaching."[4] With full-time teachers and "a daily assembly of the saints, at which the Word was preached,"[5] it is hard to imagine these various ministers engaged in "teaching" that steadfastly avoided the explanation of all biblical texts.

Of course, the true teachers *were* passing on the apostolic deposit, but this does not mean they were simply repeating the sayings of Jesus. In the *Didache*, parents are told to teach (*didaxeis*) the fear of the Lord to their children (4:9). The author(s) apparently does not think teaching is restricted to a highly technical definition. Nor does he think preaching is little more than a running commentary plus application. "My child, remember night and day the one who preaches God's word to you, and honor him as though he were the Lord. For wherever the Lord's nature is preached, there the Lord is" (4:1). According to the *Didache*, teaching is broader than transmitting oral traditions, and preaching involves more than a few words of exhortation.

## Teaching in the Synagogue

One of the key points in Dickson's argument is that the Pauline conception of teaching is rooted in the practice of the Pharisees, who passed on the oral traditions of their fathers (Mark 7:7). Just

as the Pharisees might repeat the sayings of Hillel, so might the New Testament teacher repeat the sayings of Jesus. According to Dickson, the closest parallel to New Testament "teaching" is the passing down of the rabbinical traditions that we find repeated and piled up in the *Mishnah* (p. 39).

This is an important line of reasoning for Dickson, one he repeats several times (pp. 39, 73, 100–102). The problem with the argument is twofold.

First, while the *Mishnah* collects the sayings of first- and second-century rabbis, these rabbis saw themselves explaining and applying the Torah. In other words, even if the *Mishnah* is our example of "teaching," there is no bright line between "oral tradition" and "explaining texts."

Second, the Jewish synagogue service provides a much better parallel to early Christian worship services than the *Mishnah*. After all, Paul is talking about corporate worship in 1 Timothy 2. For centuries leading up to the Christian era, the Jews had cultivated the art of preaching and gave it a privileged place in synagogue worship. According to Old, "there was a large core of dedicated men who had given their lives to the study of the Scriptures, and who prepared themselves to preach when the leadership of the synagogue invited them to do so."[6] It makes more sense to think Paul had in mind the well-developed tradition of men doing exposition in the Jewish worship service, when he prohibits women from teaching in 1 Timothy 2:12, as opposed to the mere repetition of oral traditions.

## Teaching in the Old Testament

What's more, this synagogue teaching ministry had its roots in the Old Testament. Moses taught the people the statutes and rules of

God—repeating them, yes, but also explaining and applying them (Deut. 4:1–14). The word "taught" in verse 5 is *didaskō* in the Greek Septuagint (LXX), the translation of the Hebrew Scriptures used in the first century. The priests, at least some of them, were to be teaching priests (2 Chron. 15:3), going through the cities of Judah teaching (*edidaskon*, LXX) people the Book of the Law (2 Chron. 17:9). Ezra set his heart to study the law of the Lord and to teach (*didaskein*, LXX) his statutes and rules in Israel (Ezra 7:10). Likewise, Ezra and the Levites read from the law of God and taught (*edidasken*, LXX) the people so they could understand the reading (Neh. 8:8).

The practices described in Ezra and Nehemiah give every indication of already being well established. There are texts, there are teachers, there is a congregation. We have in miniature the most essential elements of Jewish synagogue services and the Christian services that would use synagogue worship as their starting point. It's hard to imagine Paul meant to communicate, let alone that his audience would understand, that when he spoke of "teaching" he had in mind nothing of the Old Testament or Jewish tradition and was thinking only of Pharisees passing along oral sayings. In each of the Old Testament instances above, the teacher explains a written text. That doesn't mean *didaskō* must involve exposition, but the burden of proof rests with those who assert that it most certainly does not mean that.

### Teaching in the New Testament

I agree with Dickson that the prohibition against women teaching in 1 Timothy 2:12 should not be taken in the broadest sense possible. Paul does not mean to forbid women from ever transmitting

knowledge to someone else. He is addressing propriety in worship, not the sort of teaching we find from women to women in Titus 2 or from Priscilla and Aquila to Apollos in Acts 18. But just because we reject the broadest definition of teaching does not mean the only other option is the narrowest definition. Dickson would have us equate "teaching" with passing on oral tradition. That was certainly part of teaching in the apostolic age, but many of the places in the New Testament that speak of the apostolic tradition never mention *didaskō* (1 Cor. 2:2; 3:10; 11:2, 23–26; 15:1–11; Gal. 1:6–9; 1 Thess. 4:1–2). The language instead is of receiving, delivering, or passing on.

Crucially, the Sermon on the Mount is labeled as "teaching" (Matt. 7:28–29). According to Dickson, the Sermon on the Mount is "teaching" because Jesus is correcting the tradition of the scribes and handing down his own authoritative traditions. What Jesus is not doing is expositing a text (p. 54). Of course, Dickson is right in what Jesus *is* doing. He is wrong, however, in asserting what Jesus is *not* doing. The Sermon on the Mount is filled with Old Testament allusions, parallels, and explanations. One does not have to claim that Jesus is giving a modern sermon. The point is not that "teaching" everywhere in the New Testament means "exposition," but that the two ideas cannot be neatly separated.

The first-century Jewish understanding of teaching must not be separated from the judicious interpretation of inspired texts. Jesus was recognized by many as "rabbi," an informal title meaning "teacher." As a teacher, Jesus frequently quoted from or explained Old Testament Scripture. In fact, Old argues that Jesus's teaching in the temple courts at the end of his ministry was meant to show

Jesus as the fulfillment of the rabbinical office. In Matthew 21–23 we see the different schools of the time—Herodians, Pharisees, Sadducees—come to Jesus with their questions about the law, and Jesus answers them all.[7] In solving their riddles and stepping out of their traps, Jesus showed himself to be the master teacher, the rabbi of all rabbis. And in this display, he constantly explained and interpreted Scripture. The first-century Jewish understanding of teaching must not be separated from the judicious interpretation of inspired texts, nor can it be restricted to "passing along oral traditions."

## Teaching in the Pastoral Epistles

But what if—despite the Old Testament background and the synagogue background and the use of "teaching" in the Sermon on the Mount and the broader understanding of teacher in the early church—Paul chose to use a very narrow definition of teaching in the Pastoral Epistles? After surveying all the uses of "teaching" in the Pastoral Epistles, Dickson concludes that "teaching," as a verb and a noun, refers not to Bible exposition but to apostolic words laid down for the churches (p. 59). Simply put, "teach" does not mean exegete and apply; it means repeat and lay down (pp. 64–65). Pauline "teaching" was *never* (Dickson's word, my emphasis) exposition in the contemporary sense (p. 74). Whatever else teaching may entail in other places, according to Dickson, for Paul it only meant laying down oral tradition.

Dickson is certainly right that "teaching" in the Pastoral Epistles is about passing on the good deposit of apostolic truth about Jesus. Conservative scholar William Mounce, for example, has no problem affirming that 1 Timothy 2:12 has to do with "the

authoritative and public transmission of tradition about Christ and the Scriptures" or that it involves "the preservation and transmission of the Christian tradition."[8] But notice that Mounce does not reduce the Christian tradition to oral sayings only, to the exclusion of scriptural explication. Likewise, the *Theological Dictionary of the New Testament* (*TDNT*) argues that *didaskein* "is closely bound to Scripture even in the NT."[9] Later the *TDNT* affirms that even in the Pastoral Epistles "the historical connexion between Scripture and *didaskein* is still intact."[10]

Surely this is right. Are we really to think that when Paul insisted that the elders be able to teach that this had no reference to handling the Scriptures or rightly dividing the word of truth (2 Tim. 2:15)? Teaching must be broader than passing on oral traditions, for how else could Paul tell the older women "to teach what is good" (*kalodidaskalos*) to the younger women? Or consider 1 Timothy 4:13, where Paul tells Timothy to devote himself to the public reading of Scripture, to exhortation, and to teaching. Sure, these are not identical tasks, but on Dickson's interpretation Timothy was to read the Scriptures, exhort from the Scriptures, and then lay down the apostolic deposit without making exposition constitutive of his task.

Similarly, Dickson argues that when Paul says all Scripture is profitable for teaching, he means Timothy would privately read Scripture so that he could be better equipped to publicly pass on the good deposit, but again, without expounding a Bible passage (pp. 52–53). If this is correct, then Paul did not envision teachers doing much with the exposition of Scripture in reproving, correcting, or training either. The Bible may inform these tasks, but it never involves exposition (p. 57). This finely tuned

definition of teaching is not convincing. Look at the preaching in Acts. There was hardly any handing down of the good deposit that did not also explain the Scriptures. And in 1 Corinthians 15 where Paul is *explicitly* passing along what he also received, the message is not the mere repetition of verbal formulas, but the apostolic tradition that Christ died for our sins *in accordance with the Scriptures* and that he was raised on the third day *in accordance with the Scriptures*. One does not have to equate *didaskō* with a three-point sermon to see that transmitting the apostolic deposit can scarcely be done apart from biblical references and exposition.

### Teaching in Today's Sermon

If Dickson's definition of ancient teaching is too narrow, his understanding of contemporary preaching is too thin. In Dickson's telling, the sermon is essentially a running commentary plus application. I confess I have a very different view of what preaching entails, not because preaching is less than exposition and application, but because it is much more. The preacher is a *kērux*, a herald (2 Tim. 1:11). Of course, we don't preach with the authority of an apostle, but for those qualified men called to preach, they *do* pass along the apostolic deposit, and they *ought* to preach with authority. Why else would Paul command Timothy—with such dramatic language and with such dire exhortations—to preach the word; to reprove, rebuke, and exhort, with complete patience and teaching (2 Tim. 4:1–2)?

In the end, I believe Dickson's approach is not only historically and exegetically unconvincing; it is practically unworkable—at least for complementarians. Others may affirm women preaching for all sorts of reasons. But complementarians who try to

thread the needle and argue that "this message on Sunday morning is a sharing, not a sermon" or "this woman preaching is under the authority of the session" will find that their arguments for not letting women preach all the time and in any way look exceedingly arbitrary.

The heraldic event—no matter the platform provided by the pastor or the covering given by the elders—cannot be separated from exercising authority and teaching, the two things women are not permitted to do in the worship service.

At various points, Dickson admits that some preaching today may involve teaching and that the different kinds of speaking in the New Testament probably overlapped:

- I am not suggesting that these three forms of speech (teaching, prophesying, and exhorting) are strictly separate or that there is no significant overlap of content and function. (p. 24)

- *Some* contemporary sermons involve something close to authoritatively preserving and laying down the apostolic deposit, but I do not believe this is the typical function of the weekly exposition. (p. 64)

- I have no doubt that Timothy added to these apostolic teachings his own appeals, explanations, and applications, but these are not the constitutive or defining elements of teaching. At that point, Timothy would be moving into what is more appropriately called "exhortation." (p. 65)

- I am not creating a hard distinction between teaching and exhorting, but I am observing that, whereas teaching is principally

about laying something down in fixed form, exhorting is principally about urging people to obey and apply God's truth. (p. 65)

- No doubt there was a degree of teaching going on in exhorting and prophesying, just as there was some exhorting (and maybe prophesying) going on in teaching. (pp. 66–67)

- I also think that some transmission of the apostolic deposit still goes on in every decent sermon, in some more than others. (p. 79)

With all these elements of preaching jumbled together, how could Paul have expected Timothy to untangle the ball of yarn and know what he was supposed to not permit women to do? Just as importantly, how are we to discern when a sermon is just exhortation without authority and when it moves into an authoritative transmission of the apostolic deposit? Perhaps it would be better to see "teaching" as more or less what the preacher does on Sunday as opposed to a highly technical term that doesn't make sense out of the early church, the Jewish synagogue, Jesus's example, or Paul's instructions.

The heraldic event—no matter the platform provided by the pastor or the covering given by the elders—cannot be separated from exercising authority and teaching, the two things women are not permitted to do in the worship service.

# Notes

## Introduction

1. David Clay Large, "Thanks. But No Cigar," in *What If? The World's Foremost Military Historians Imagine What Might Have Been*, ed. Robert Cowley (New York: Berkley, 2000), 290–91.

2. This paragraph is a summary of, and in some places borrows sentences from, my book *What Does the Bible Really Teach about Homosexuality?* (Wheaton, IL: Crossway, 2015), 32.

3. The present book is, in part, a revision of a book I self-published called *Freedom and Boundaries: A Pastoral Primer on the Role of Women in the Church* (Enumclaw, WA: Pleasant Word, 2006). After the self-publishing company went belly-up and the book went out of print (you can purchase it for $99 from hoarders on Amazon!), Crossway asked if I'd be interested in doing a new edition of the book. As you might imagine, many of the controversies have changed in the last fifteen years. My context also changed— from Reformed Church in America, which ordains women, to Presbyterian Church in America, which does not. Thankfully, my exegetical conclusions are almost entirely the same. The end result: most of the exegesis has been carried over from the earlier book to this one, but everything has been reworked, and over half the total material is new.

4. Andreas J. Köstenberger and Margaret E. Köstenberger, *God's Design for Man and Woman: A Biblical-Theological Survey* (Wheaton, IL: Crossway, 2014); Sharon James, *God's Design for Women in an Age of Gender Confusion*, rev. ed. (Durham, UK: Evangelical Press, 2019);

Claire Smith, *God's Good Design: What the Bible Really Says about Men and Women*, 2nd ed. (Kingsford, Australia: Matthias Media, 2019). See also *Recovering Biblical Manhood and Womanhood*, ed. John Piper and Wayne Grudem (Wheaton, IL: Crossway, 2006). This seminal resource, first published in 1991, is outdated in places, but the first two sections in particular ("Vision and Overview" and "Exegetical and Theological Studies") still repay careful reading.

### Chapter 1: A Very Good Place to Start

1. This language comes from Alistair Roberts, "Man and Woman in Creation (Genesis 1 and 2)," in, *Is Complementarianism in Trouble?: A Moment of Reckoning, 9Marks Journal* (December 2019): 35.
2. Roberts, "Man and Woman in Creation," 37.
3. John Calvin, *Commentaries on the Book of Genesis*, vol. 1 (Grand Rapids, MI: Baker, 1979), 133.
4. Gordon J. Wenham, *Genesis 1–15*, vol. 1, Word Biblical Commentary (Grand Rapids, MI: Zondervan, 1987), 81.
5. Roberts, "Man and Woman in Creation," 38.

### Chapter 2: Patterns That Preach

1. For the distinction between these terms, see Andreas J. Köstenberger and Margaret E. Köstenberger, *God's Design for Man and Woman: A Biblical-Theological Survey* (Wheaton, IL: Crossway, 2014), 60.
2. Of course, we also see in the New Testament how fathers are essential in training up children (Eph. 6:4; Col. 3:21), but even here, the father's role focuses on discipline (Heb. 12:7), while the typical maternal role focuses on nurture and affection (1 Thess. 2:7–8).

### Chapter 4: Of Heads and Hair

1. For more on these themes see Kevin DeYoung, *Taking God at His Word: Why the Bible Is Knowable, Necessary, and Enough, and What That Means for You and Me* (Wheaton, IL: Crossway, 2014).
2. Roy E. Ciampa and Brian S. Rosner, *The First Letter to the Corinthians* (Grand Rapids, MI: Eerdmans, 2010), 509. For more on *kephale* see Wayne Grudem, *Evangelical Feminism and Biblical Truth: An Analysis of More than 100 Disputed Questions* (Wheaton, IL: Crossway, 2012), 201–11, 544–99.

3. John Calvin, *Men, Women, and Order in the Church: Three Sermons by John Calvin*, trans. Seth Skolnitsky (Dallas: Presbyterian Heritage, 1992), 16.

4. See Kyle Harper, *From Shame to Sin: The Christian Transformation of Sexual Morality in Late Antiquity* (Cambridge, MA: Harvard University Press, 2013), 41–42.

5. See Anthony C. Thiselton, *The First Epistle to the Corinthians*, New International Greek Testament Commentary (Grand Rapids, MI: Eerdmans, 2000), 802.

6. Calvin, *Men, Women, and Order in the Church*, 55, 58.

7. Because of some variation regarding the placement of verses 34–35 in the early manuscripts, some scholars have argued that the verses are a non-Pauline addition. Nevertheless, the reasons in favor of their authenticity are strong. No textual witness lacks the verses, and the most recent edition of the Greek New Testament considers the traditional text almost certain. See Ciampa and Rosner, *First Epistle to the Corinthians*, 1148–50.

8. Cf. Thiselton, *First Epistle to the Corinthians*, 1156, 1158.

*Chapter 5: A Marriage Made in Heaven*

1. All quotations in this paragraph are taken from "Women Balk at Controversial Nominee," *Fox News* website, July 10, 2004, http://www.foxnews.com/printer_friendly_story/0,3566,124885,00.html. As I completed final edits for this book, I noticed the same objections were being raised against Amy Coney Barrett's nomination to the Supreme Court because of her association with conservative Catholic views on male headship in the home.

2. John Witherspoon, "Lectures in Moral Philosophy," in *The Selected Writings of John Witherspoon*, ed. Thomas Miller (Carbondale, IL: Southern Illinois University Press, 1990), 196.

3. John Witherspoon, "Letters on Marriage," in *The Works of the Rev. John Witherspoon*, 4 vols., 2nd ed. (Philadelphia: Woodward, 1802), 4:168.

4. John Chrysostom, *Chrysostom: Homilies on Galatians, Ephesians, Philippians, Colossians, Thessalonians, Timothy, Titus, and Philemon*, vol. 13, *Nicene and Post-Nicene Fathers* (Peabody, MA: Hendriksen, 2004), 144.

5. John Calvin, *Commentaries on the Epistle of Paul to the Ephesians*, vol. 21, Calvin's Commentaries, trans. W. Pringle (Grand Rapids, MI: Baker, 1993), 322.

6. Edgar Rice Burroughs, *Tarzan of the Apes* (New York: Modern Library, 2003), 143.

7. Mary Eberstadt, *Primal Screams: How the Sexual Revolution Created Identity Politics* (West Conshohocken, PA: Templeton Press, 2019), 75.

8. Wendy Shalit, *A Return to Modesty* (New York: Free Press, 1999), 144–45.

9. D. L. Moody, *The Overcoming Life and Other Sermons* (Chicago: Bible Institute Colportage Association, 1896), 13–14.

## Chapter 6: The Heart of the Matter

1. This brief reconstruction of Ephesus is indebted to S. M. Baugh's "A Foreign World: Ephesus in the First Century," in *Women in the Church: An Analysis and Application of 1 Timothy 2:9–15 (Third Edition)*, ed. Andreas J. Köstenberger and Thomas R. Schreiner (Wheaton, IL: Crossway, 2016), 25–64.

2. See Andreas J. Köstenberger, "A Complex Sentence: The Syntax of 1 Timothy 2:12," in *Women in the Church*, 117–61.

3. For the definitive defense of this conclusion see Al Wolters, "The Meaning of Αὐθεντέω," in *Women in the Church*, 65–115.

## Chapter 7: Leaders, Servants, and Life Together

1. For more, exegetically and historically, on the women and the diaconate, see Cornelis Van Dam, *The Deacon: Biblical Foundations for Today's Ministry of Mercy* (Grand Rapids, MI: Reformation Heritage, 2016), 77–92, 113–30.

2. Cf. John Piper, "A Vision of Biblical Complementarity: Manhood and Womanhood Defined According to the Bible," in *Recovering Biblical Manhood and Womanhood*, ed. John Piper and Wayne Grudem (Wheaton, IL: Crossway, 2006), 58.

## Chapter 8: Common Objections

1. It is also worth pointing out that the "one another" language does not always imply reciprocity. See, for example, Matt. 24:10; Luke 12:1; 1 Cor. 7:5; 11:33.

2. John Chrysostom, *Chrysostom: Homilies on Galatians, Ephesians, Philippians, Colossians, Thessalonians, Timothy, Titus, and Philemon,*

vol. 13, *Nicene and Post-Nicene Fathers* (Peabody, MA: Hendriksen, 2004), 143.

3. Chrysostom, *Chrysostom: Homilies*, 159.

4. See Esther Yue L. Ng, "Was Junia(s) in Rom 16:7 a Female Apostle? And So What," *Journal of the Evangelical Theological Society* 63.3 (2020): 517–33. Ng argues persuasively that Junia was most likely a man, that Paul thought of apostles as men, and that Andronicus and Junia were well known *to* the apostles, not well known *as* apostles.

5. Sarah Hinlicky Wilson, "Ordaining Women: Two Views," *First Things* (April 2003): 42.

## Chapter 9: Growing Up as Boys and Girls

1. A version of this chapter was previously published as "How Are Men and Women Different?," *9Marks Journal*, December 11, 2019, https://www.9marks.org/article/how-are-men-and-women-different/ ?lang=de.

2. These two paragraphs pull from the chapter "Manliness as Stereotype," in Harvey C. Mansfield, *Manliness* (New Haven, CT: Yale University Press, 2006), 22–49. The insight about not playing with girls because they are too rough comes from Eleanor Maccoby, cited on p. 28.

3. Gordon Fee, *The First Epistle to the Corinthians*, New International Commentary on the New Testament (Grand Rapids, MI: Eerdmans, 1987), 828.

4. "Confidence in the face of risk" is Mansfield's definition of manliness in *Manliness*, 23.

## Chapter 10: Following Christ as Men and Women

1. Herman Bavinck, *The Christian Family*, trans. Nelson D. Klooster-man (Grand Rapids, MI: Christian's Library Press, 2012), 68. As the twentieth century moved on, and especially in light of World War I, Bavinck changed some of his views on women's involvement in contemporary society. Bavinck and Abraham Kuyper increasingly found themselves in strong disagreement as Bavinck came to support the idea that women could pursue university education and enter the professional workforce. Bavinck, however, continued to affirm the realities of gender differences and never wavered in his opposition to women's ordination. The basic principles Bavinck elucidated in *The Christian Family* (originally published in Dutch in 1908) remained important convictions throughout his life, even as he became more

accommodating to some cultural changes in society. See James Eglinton, *Bavinck: A Critical Biography* (Grand Rapids, MI: Baker Academic, 2020), 236–38, 278–80, 284.

2. Bavinck, *The Christian Family*, 5.
3. Bavinck, *The Christian Family*, 8.
4. Bavinck, *The Christian Family*, 25.
5. Bavinck, *The Christian Family*, 67–69.
6. Bavinck, *The Christian Family*, 95.
7. Bavinck, *The Christian Family*, 10.
8. Bavinck, *The Christian Family*, 70.
9. Harvey C. Mansfield, *Manliness* (New Haven, CT: Yale University Press, 2006), 242.
10. Mansfield, *Manliness*, 243.
11. John Calvin, *Men, Women, and Order in the Church: Three Sermons by John Calvin*, trans. Seth Skolnitsky (Dallas: Presbyterian Heritage, 1992), 27.

*Appendix*

1. John Dickson, *Hearing Her Voice: A Biblical Invitation for Women to Preach* (Grand Rapids, MI: Zondervan, 2014). In referencing the book throughout this chapter, I will cite the page numbers in parentheses rather than with dozens of endnotes.
2. The arguments laid out in this chapter first appeared as a blog post in August 2019. Not long after I posted my article, John Dickson replied with a lengthy rebuttal (http://www.johndickson.org/blog /shouldwomenpreach). It is beyond the scope of this book (and probably beyond the desire of the reader!) for me to go point by point through his response. Not surprisingly, my post did not change his mind, and his response did not change mine. The basic thrust of his response is that I made a straw man out of his view of teaching, overlooking his insistence that the Scriptures *do* play a key role in Paul's idea of teaching but that exposition is not the defining characteristic of that teaching. At the end of this chapter—just as it was at the end of my original blog post—I include several quotations from Dickson where he nuances his view of teaching exactly along the lines of what he reinforced in his response. I don't believe I was working with a straw-man understanding of this position. More to the point, I think my critique still holds. If teaching in the

New Testament is not "constituted" or "defined" by exposition—but according to Dickson's nuanced position may have included some biblical reflection, explanation, and application—how are women allowed to preach, given that Paul prohibited women from teaching and sermons include all these elements?

3. Michael W. Holmes, *The Apostolic Fathers: Greek Texts and English Translations*, 3rd ed. (Grand Rapids, MI: Baker Academic, 2007).

4. Hughes Oliphant Old, *The Reading and Preaching of the Scriptures in the Worship of the Christian Church*, vol. 1, *The Biblical Period* (Grand Rapids, MI: Eerdmans, 1998), 256.

5. Old, *Reading and Preaching of the Scriptures*, 256.

6. Old, *Reading and Preaching of the Scriptures*, 102.

7. Old, *Reading and Preaching of the Scriptures*, 106.

8. William D. Mounce, *Pastoral Epistles*, Word Biblical Commentary (Nashville, TN: Thomas Nelson, 2000), 126.

9. *Theological Dictionary of the New Testament*, 10 vols., ed. Gerhard Kittel, trans. Gerhard Friedrich (Grand Rapids, MI: Eerdmans, 1976), 2:146.

10. *Theological Dictionary of the New Testament*, 147.

# General Index

Aaron, 37
Abigail, 39
Abraham, 36
abuse of wives, 32–33
abuse of women, 17
Adam: complete in his wife, 31; as federal head, 31; formed first, 84; named the woman, 28; names, tames, and protects, 82
African slave trade, 108
Andronicus, 157n4
Anna, 111
apostle, 112
appearance, of genders, 122–25
Artemis, 75, 76
Asiarchs, 76
"as to the Lord," 65
Athaliah, 38
authority, 51, 81–82, 104, 136

Barak, 37
barren women, 41
Barrett, Amy Coney, 155n1
Bathsheba, 40
Bavinck, Herman, 132, 133, 134, 157–58n1
Bible, on women in ministry, 109–13
"biblical manhood and womanhood," 34
biological sex, 13, 120, 132
bishop, 90
body, 120–22

braided hair, 78
Burroughs, Edgar Rice, 72
Bush, George W., 63

Cain, 32
calling, 115
Calvin, John, 28, 30; on Christ as Mediator, 53; on cultural custom, 58; on husband who does not love wife, 72; on order in creation, 136
care, 69, 72
cessationism (apostolic gifts), 60
character, of genders, 126–29
childbearing, 32, 41–42; as obedience to woman's God-given identity, 87
children, submission to parents, 104
Christ: authority over the church, 51; authority over mankind, 51; love for the church, 68; union with his church, 14
Christ and the church, analogy for marriage, 66
Christlikeness, 117
Christology, 43
Chrysostom, 71, 107
church polity, 89
Ciampa, Roy, 50
Collins, Susan, 63
complementarianism: not capricious, 133; on headship of God over Christ, 51
complementarity (term), 19
complementary sexes, 14, 17

# Scripture Index